Jim Henson's™

THE DARK CRYSTAL™

✦ ARTIST TRIBUTE ✦

Published by
ARCHAIA™

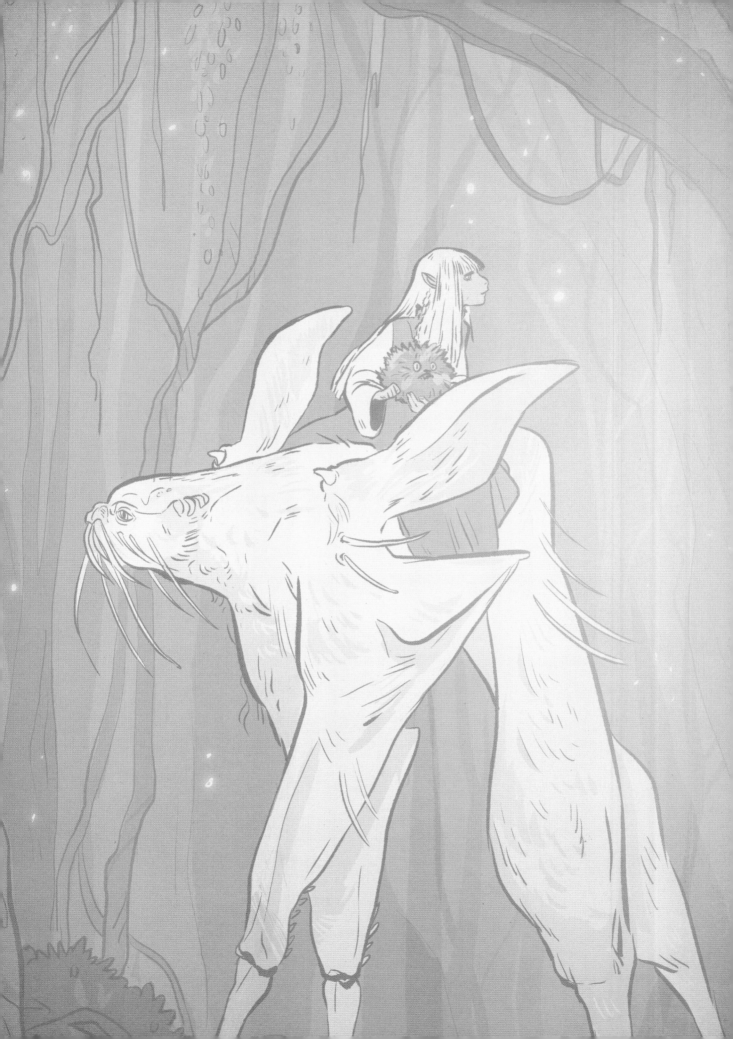

Jim Henson's™

THE DARK CRYSTAL ™

✦ ARTIST TRIBUTE ✦

Cover by
Mike Huddleston

Designer
Kara Leopard

Assistant Editor
Gavin Gronenthal

Editors
Cameron Chittock and **Sierra Hahn**

Special Thanks to Brian Henson, Lisa Henson, Jim Formanek, Nicole
Goldman, Maryanne Pittman, Carla DellaVedova, Justin Hilden, Karen
Falk, Blanca Lista, and the entire Jim Henson Company team.

JIM HENSON'S THE DARK CRYSTAL ARTIST TRIBUTE, June 2018. Published by Archaia,
a division of Boom Entertainment, Inc. © 2018 The Jim Henson Company. JIM HENSON'S mark
& logo, THE DARK CRYSTAL mark & logo, and all related characters and elements are trademarks
of The Jim Henson Company. All Rights Reserved. Archaia™ and the Archaia logo are trademarks of
Boom Entertainment, Inc., registered in various countries and categories. All characters, events, and
institutions depicted herein are fictional. Any similarity between any of the names, characters, persons,
events, and/or institutions in this publication to actual names, characters, and persons, whether living or
dead, events, and/or institutions is unintended and purely coincidental.

BOOM! Studios, 5670 Wilshire Boulevard, Suite 400, Los Angeles, CA 90036-5679.
Printed in China. First Printing.

ISBN: 978-1-68415-182-0, eISBN: 978-1-61398-997-5

✦ TABLE OF CONTENTS ✦

"Another world, another time,
in the age of wonder."

Facing Page: *Art by David Petersen.*
Following Pages: *Art by Derek Kirk Kim.* Pages 10-11: *Art by Jonathan Case.*

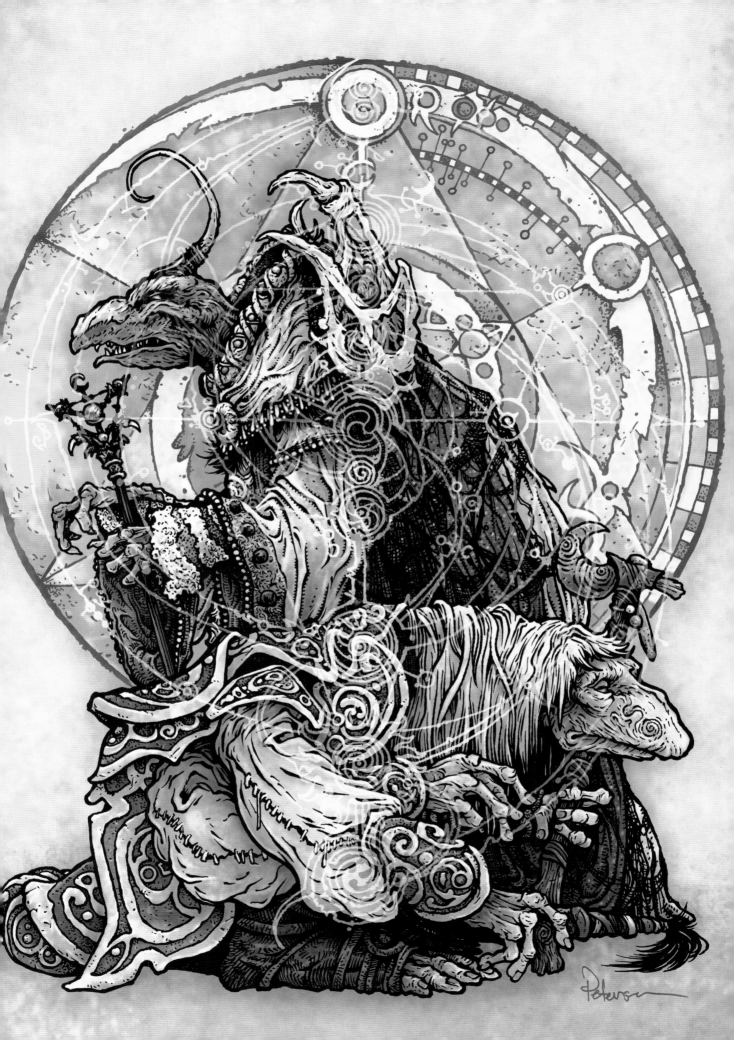

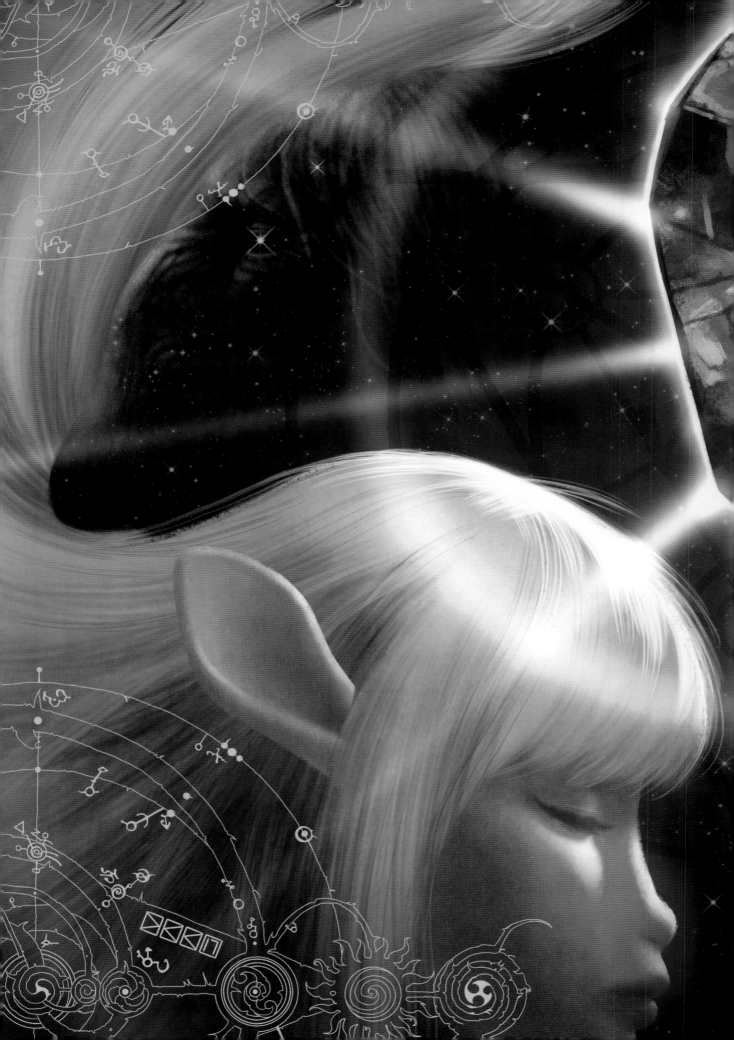

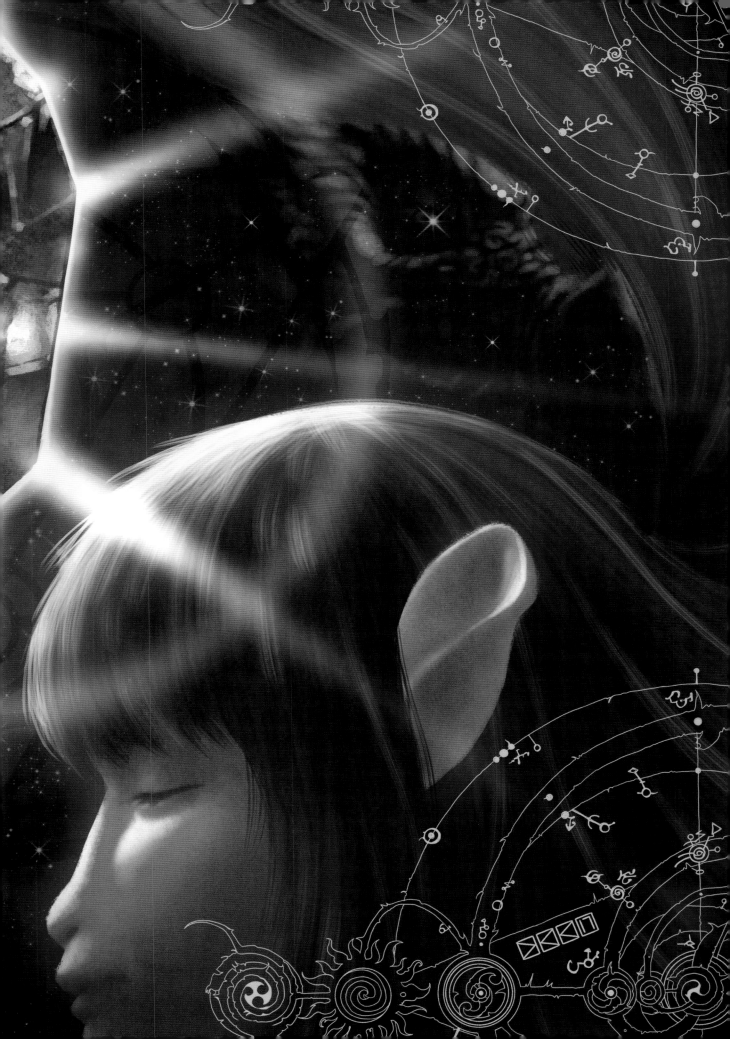

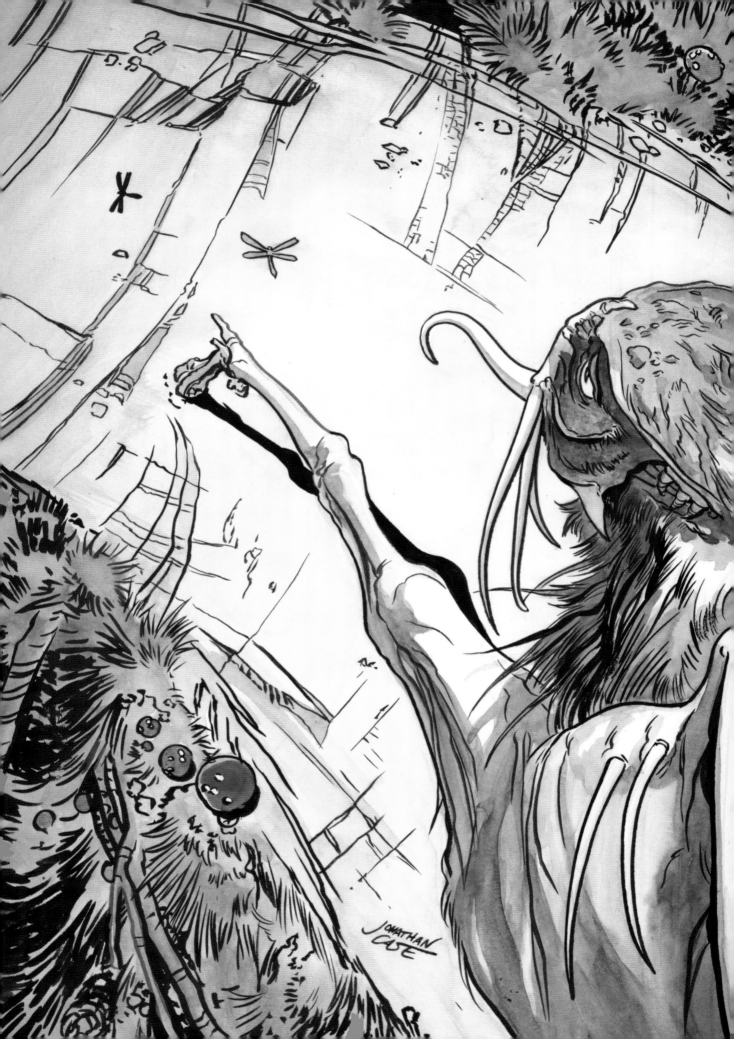

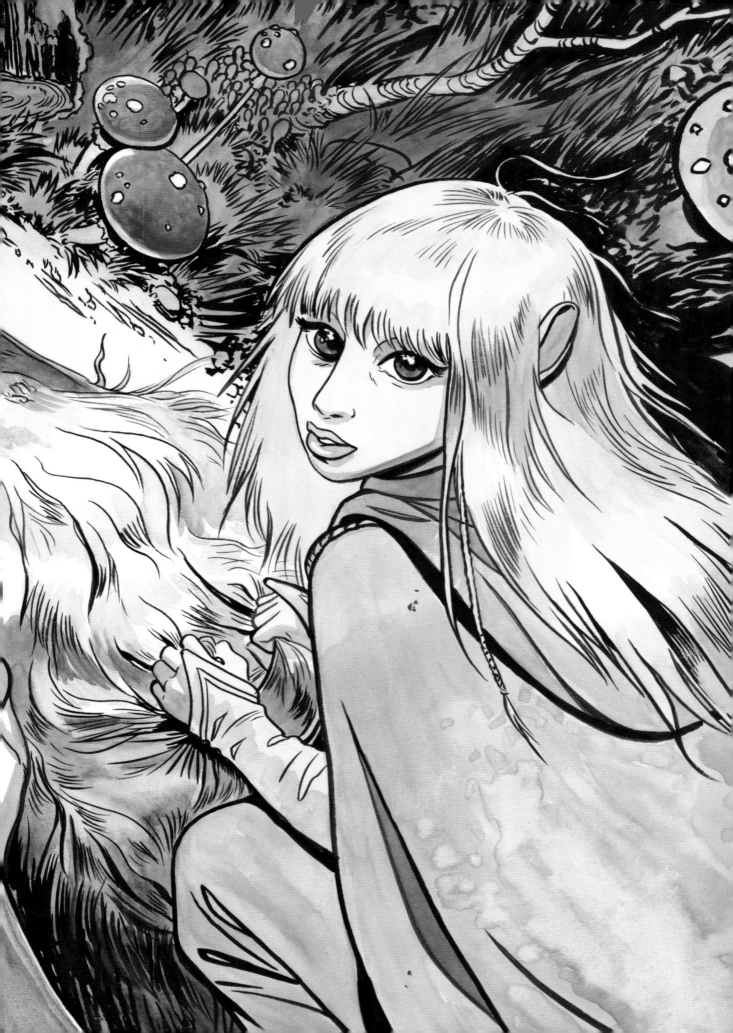

"When single shines the triple sun
What was sundered and undone
Shall be whole, the two made one
By Gelfing hand or else by none."

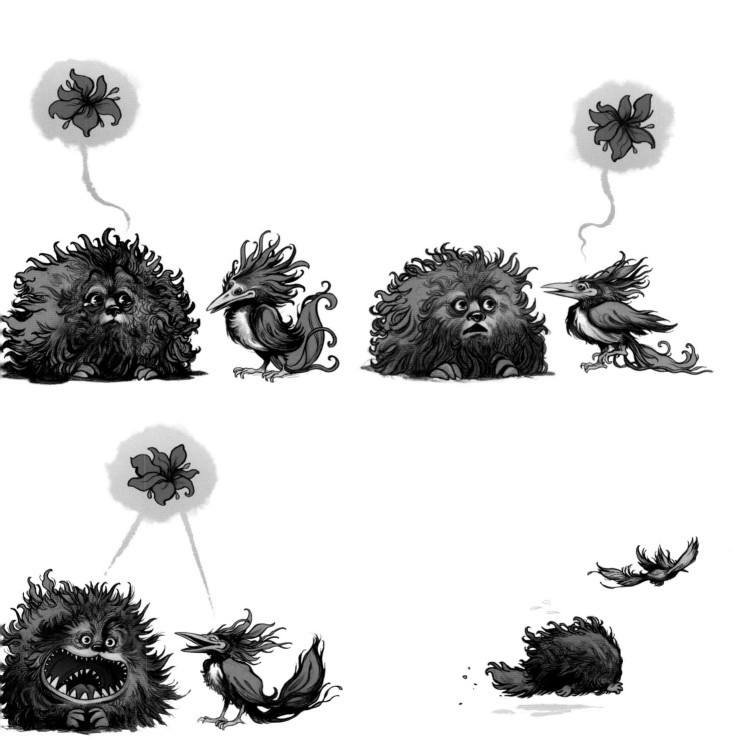

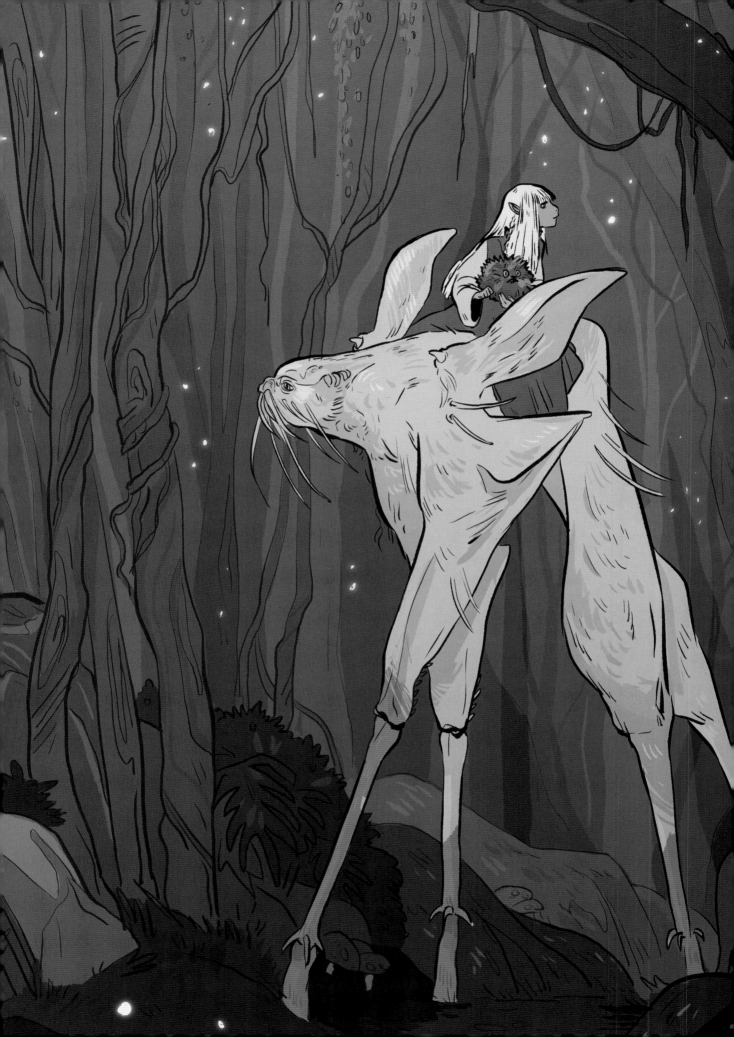

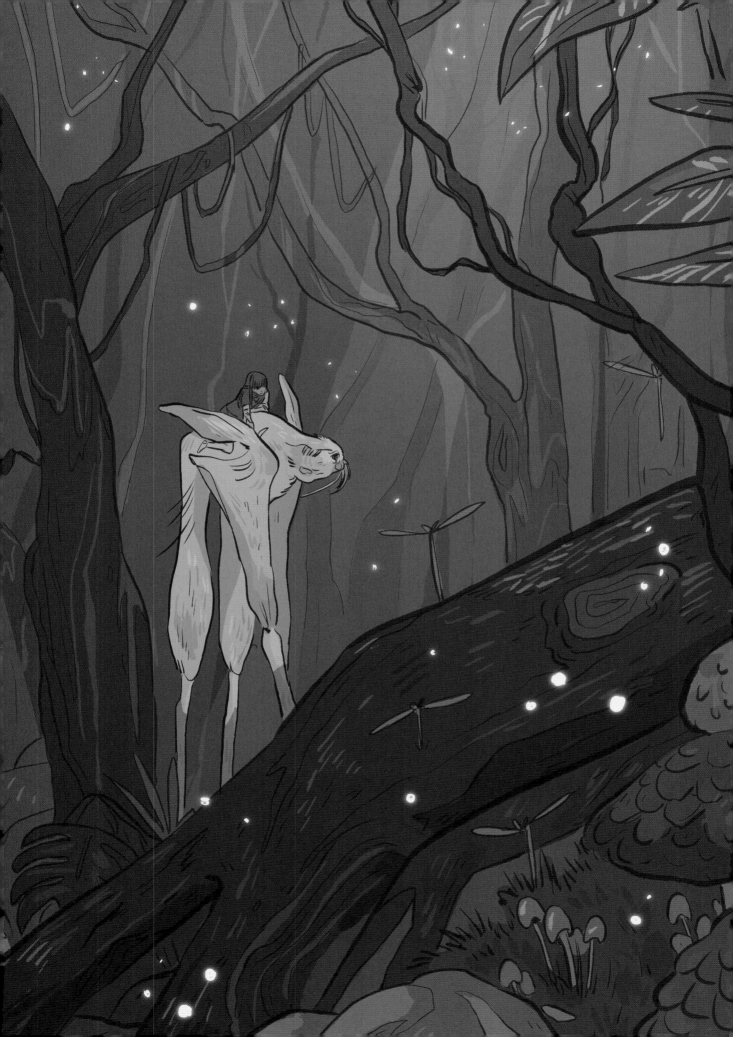

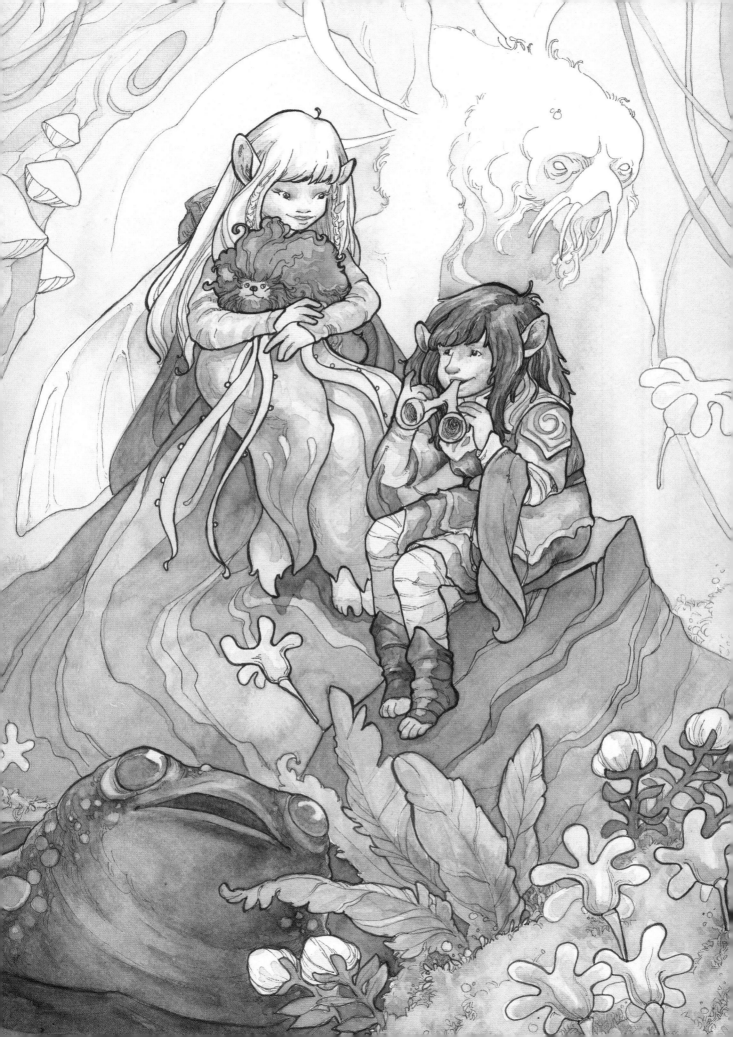

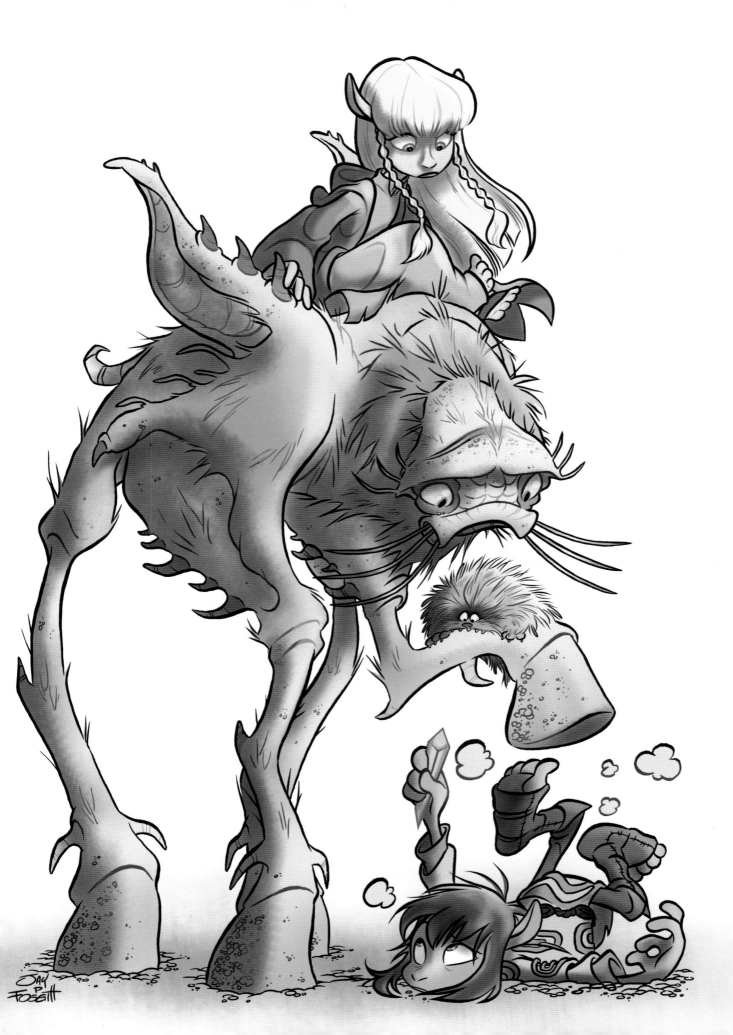

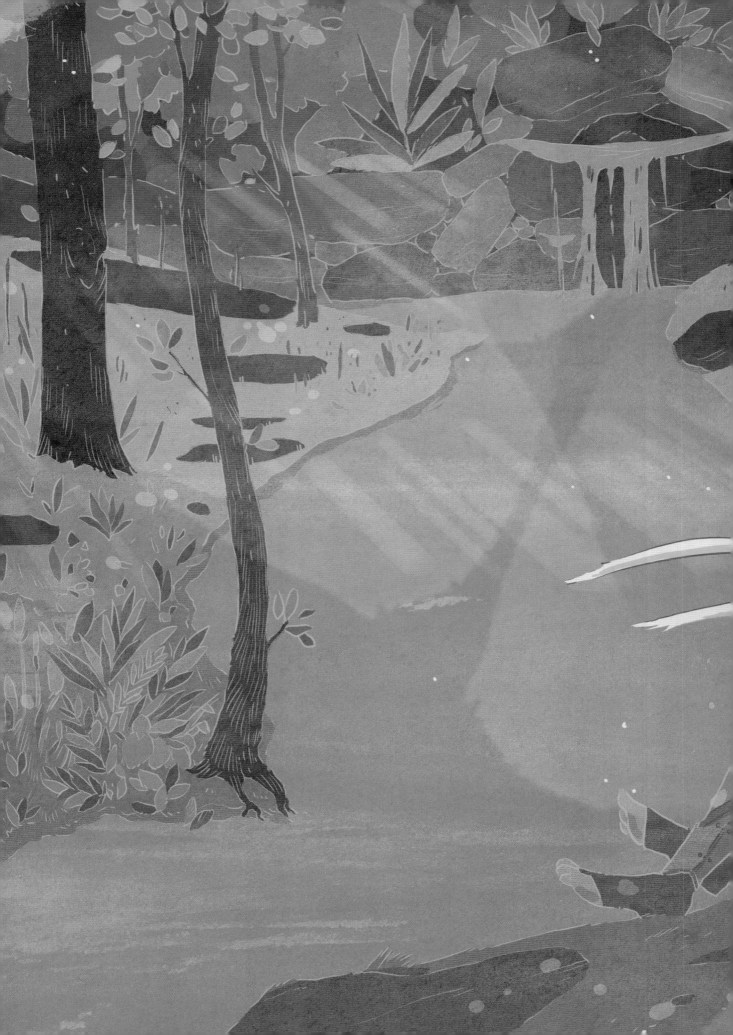

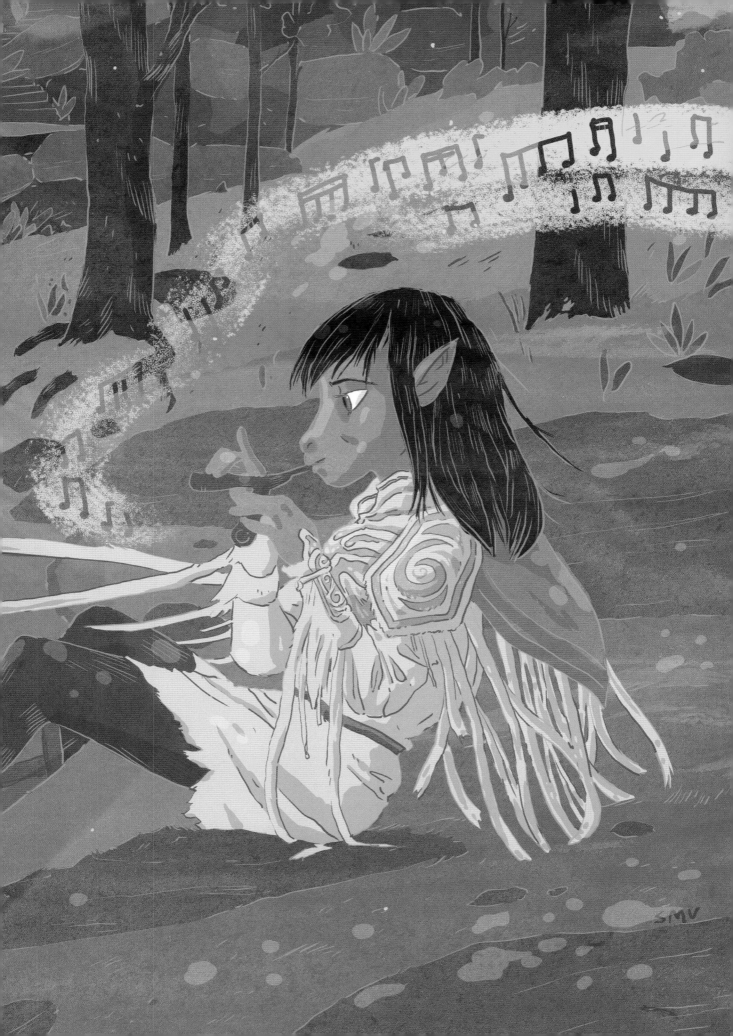

"Hold her to you, for she is part of you,
as we all are part of each other."

Previous Pages: *Art by S.M. Vidaurri*. Facing Page: *Art by Celia Lowenthal*.
Following Pages: *Art by Michael Allred with Josh Bodwell* (left) and *art by Holley Myer* (right).

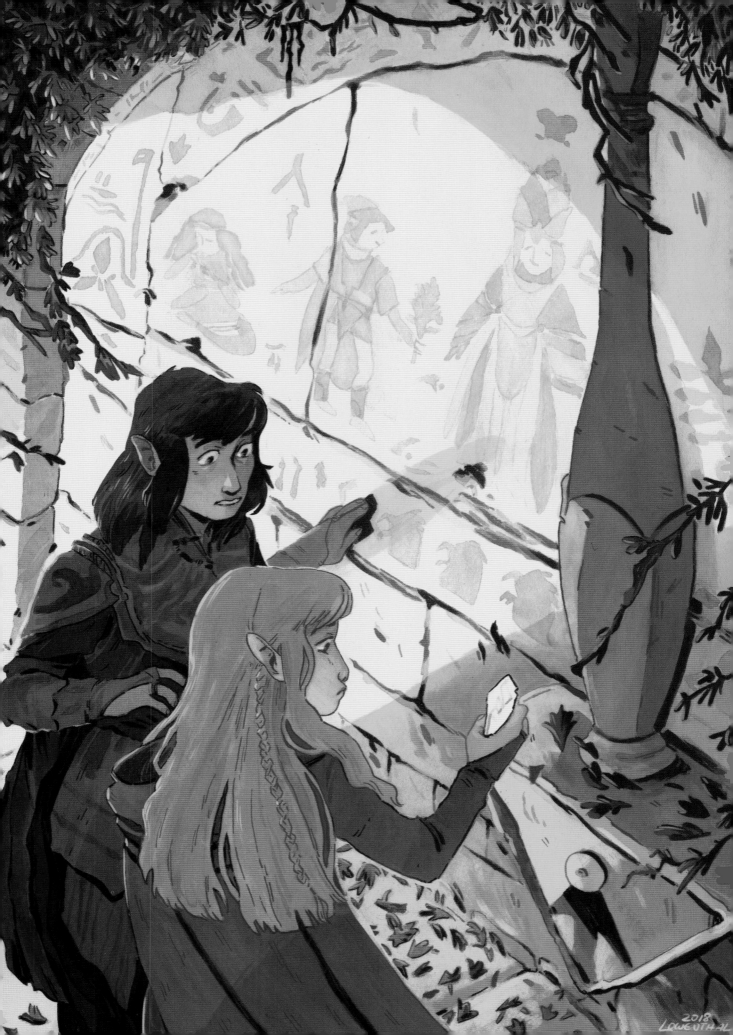

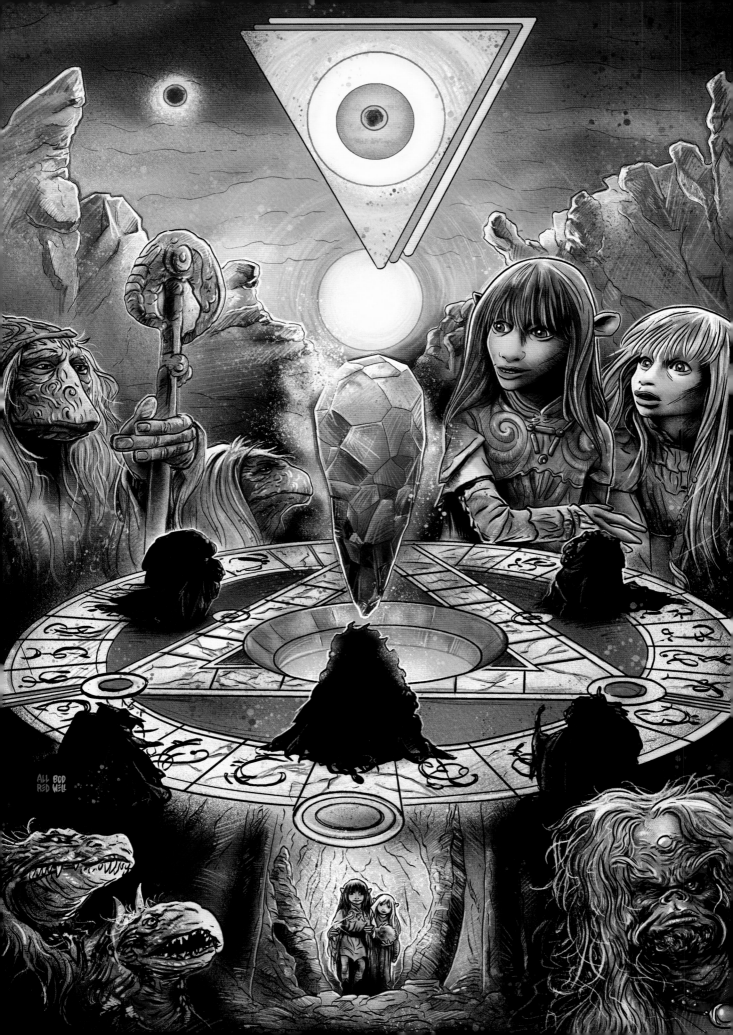

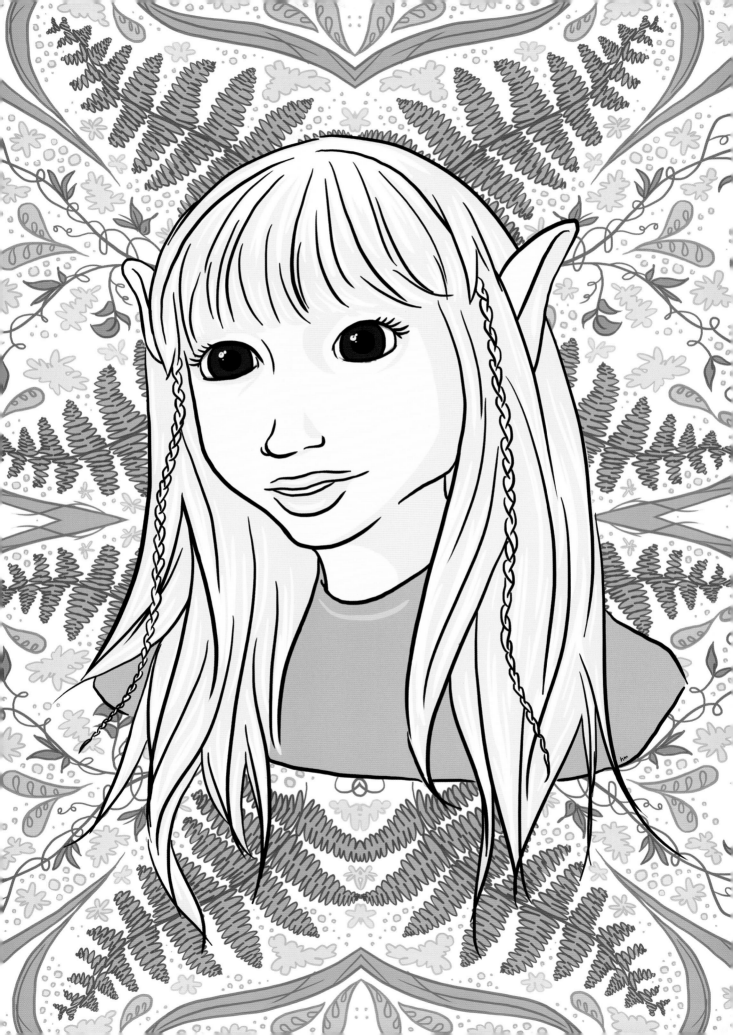

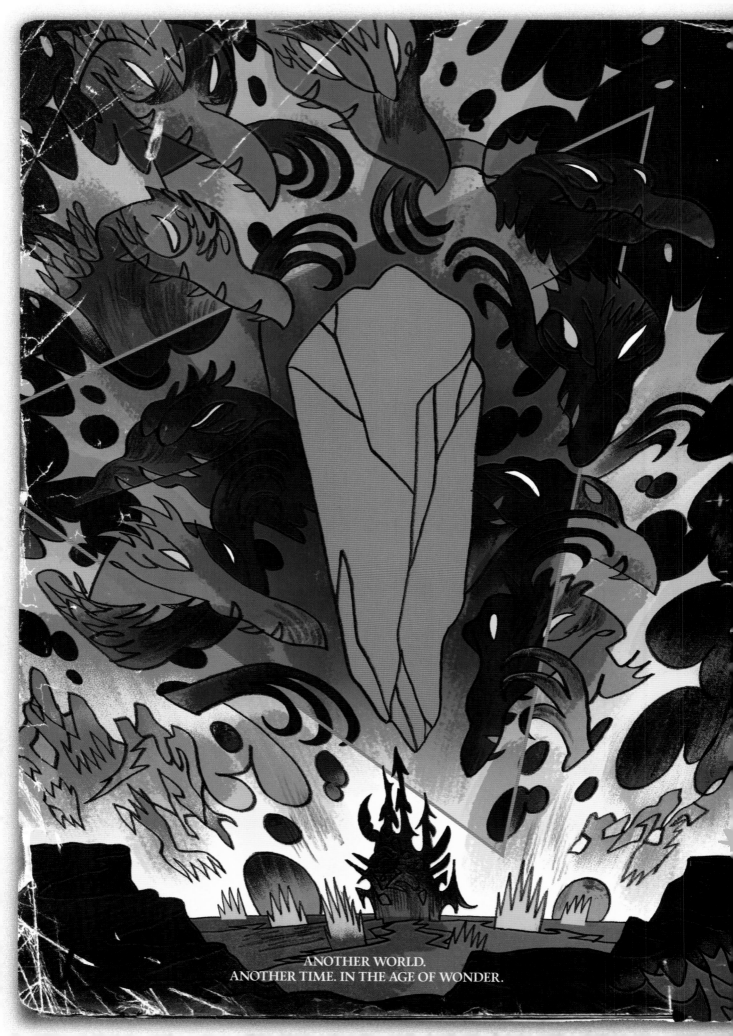

ANOTHER WORLD.
ANOTHER TIME. IN THE AGE OF WONDER.

Jim Henson™

THE DARK CRYSTAL

THE OFFICIAL
ADAPTATION OF
**THE JIM HENSON EPIC
FANTASY ADVENTURE FILM!**

"You have to heal the Dark Crystal."

Previous Pages: *Art by Benjamin Schipper*. Facing Page: *Art by Jorge Corona*.
Following Pages: *Art by Brandon Dayton* (left) and *art by Robb Mommaerts* (right).

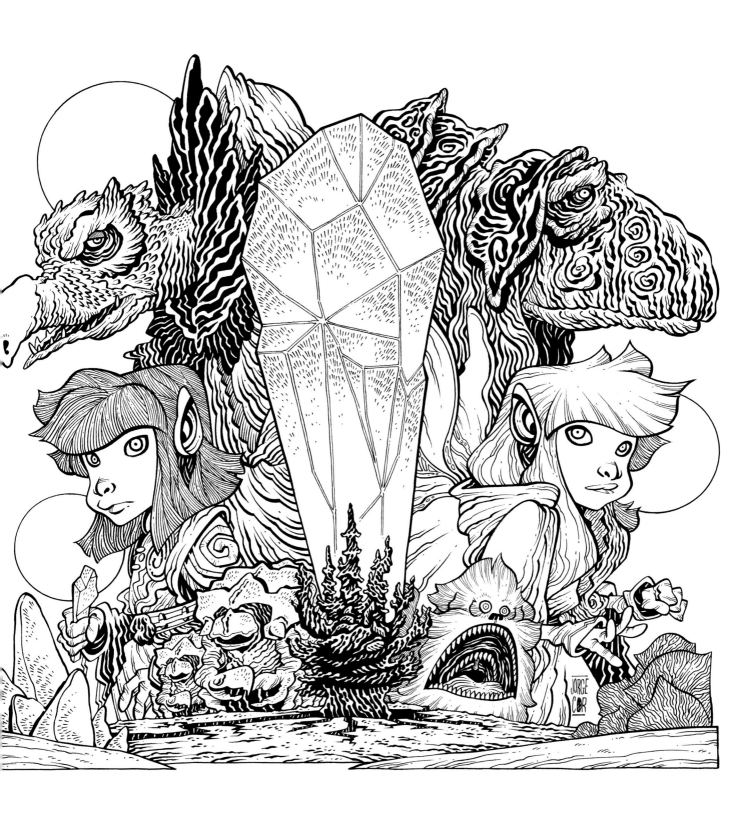

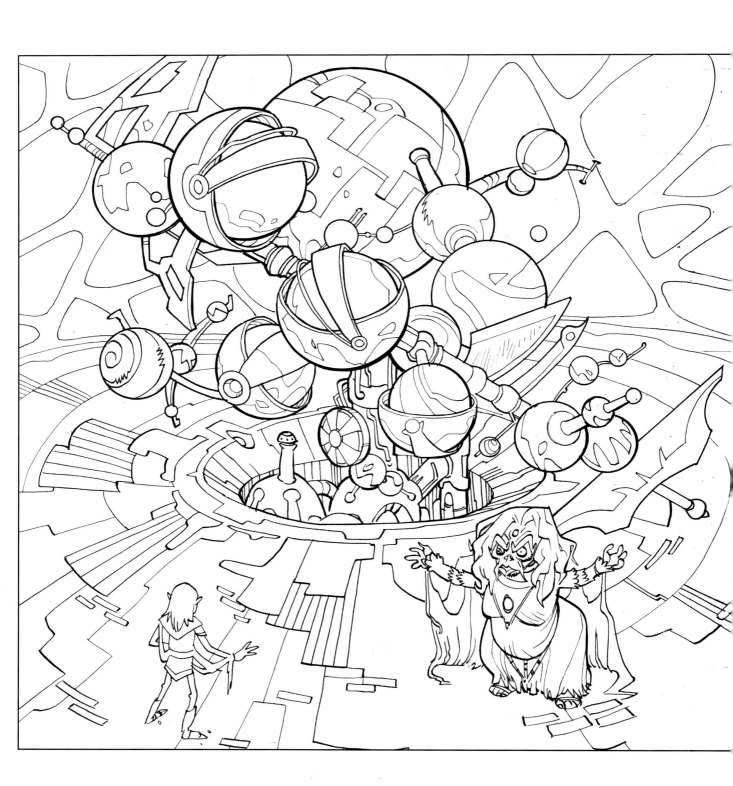

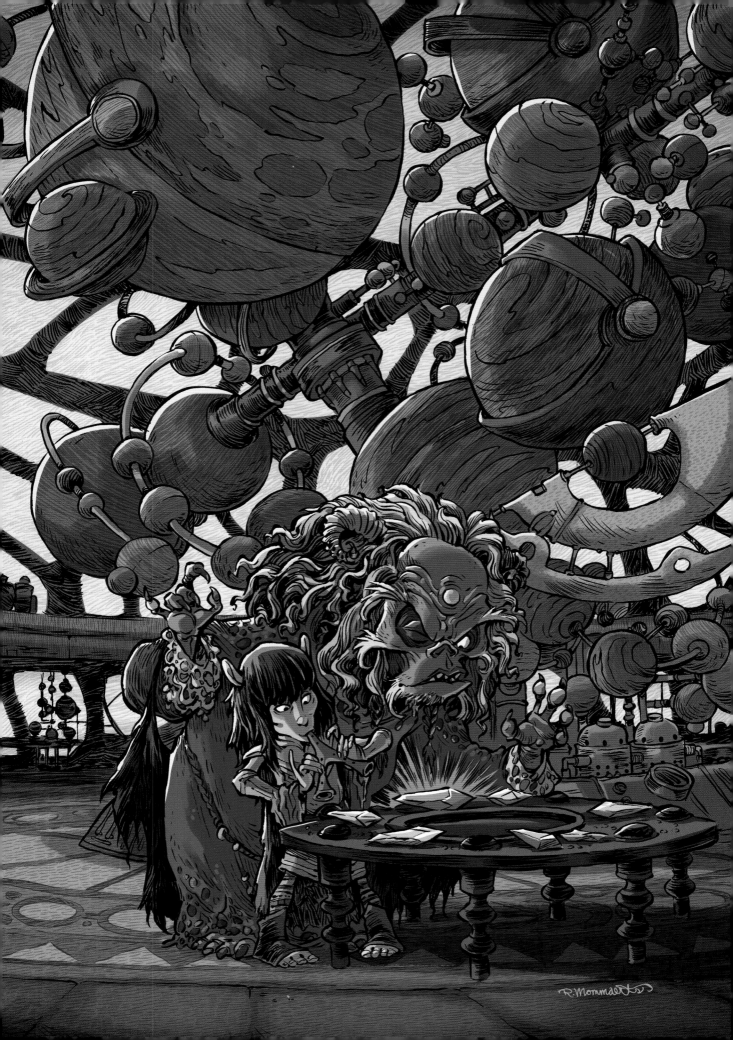

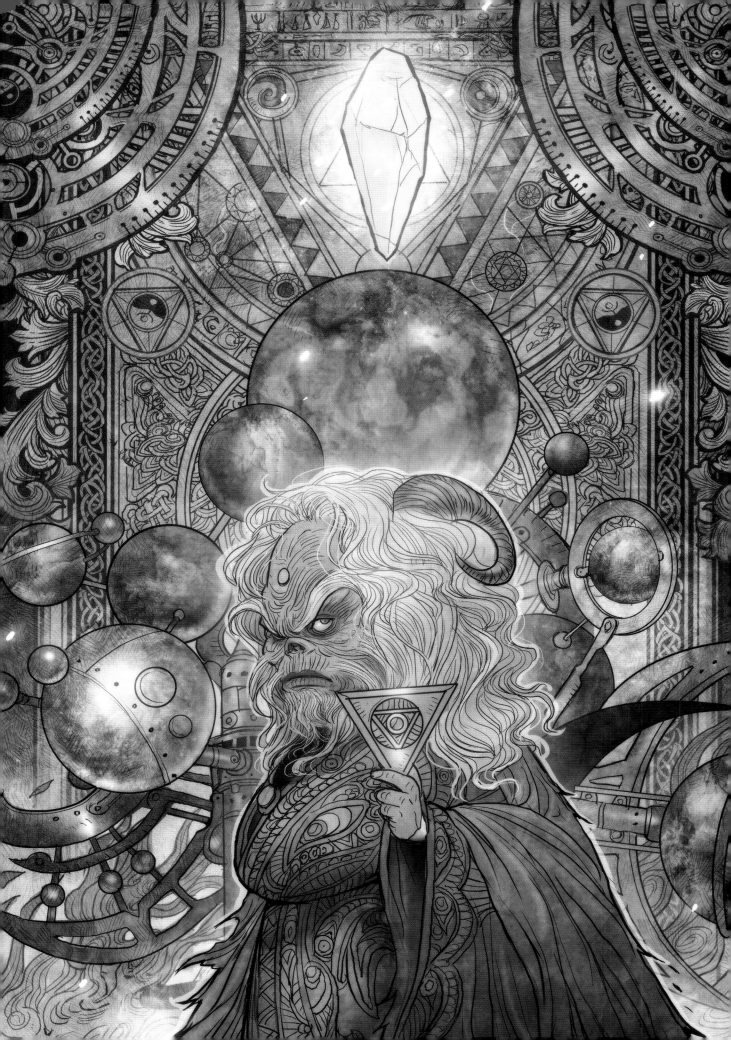

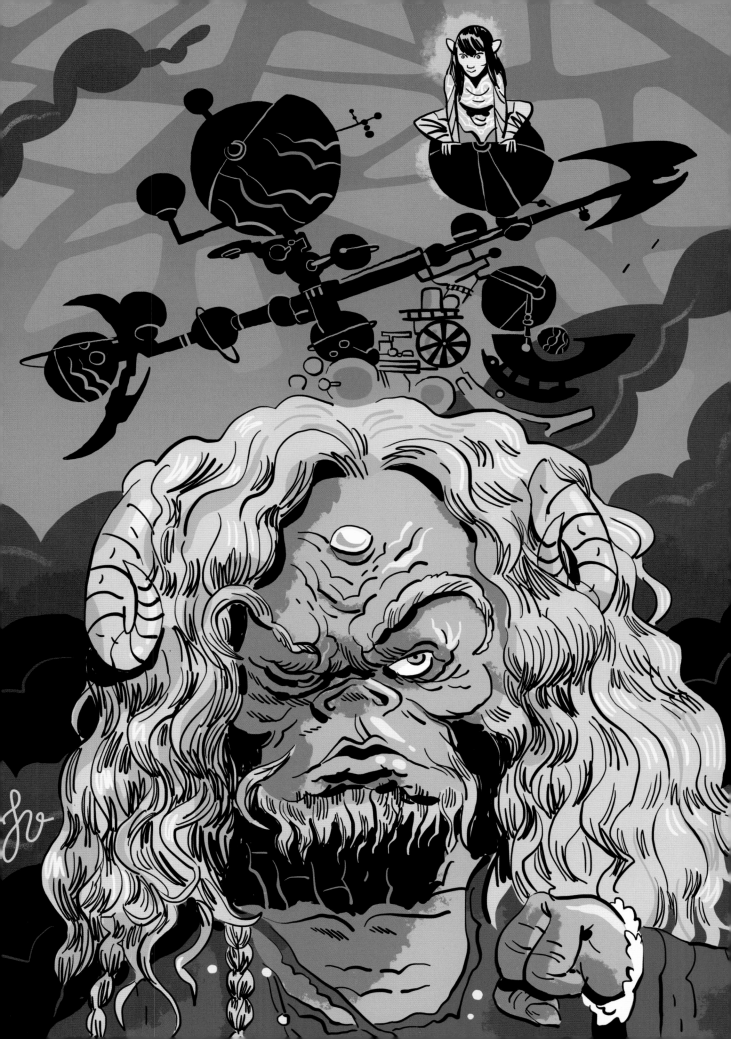

**"Another Great Conjunction coming up!
Anything could happen."**

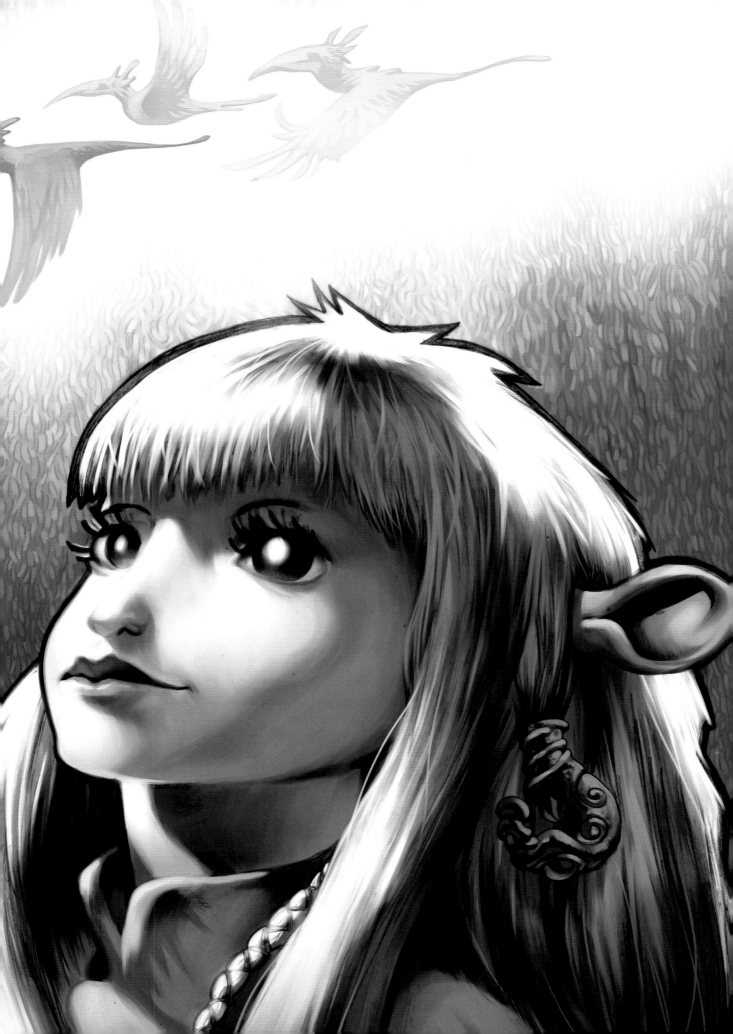

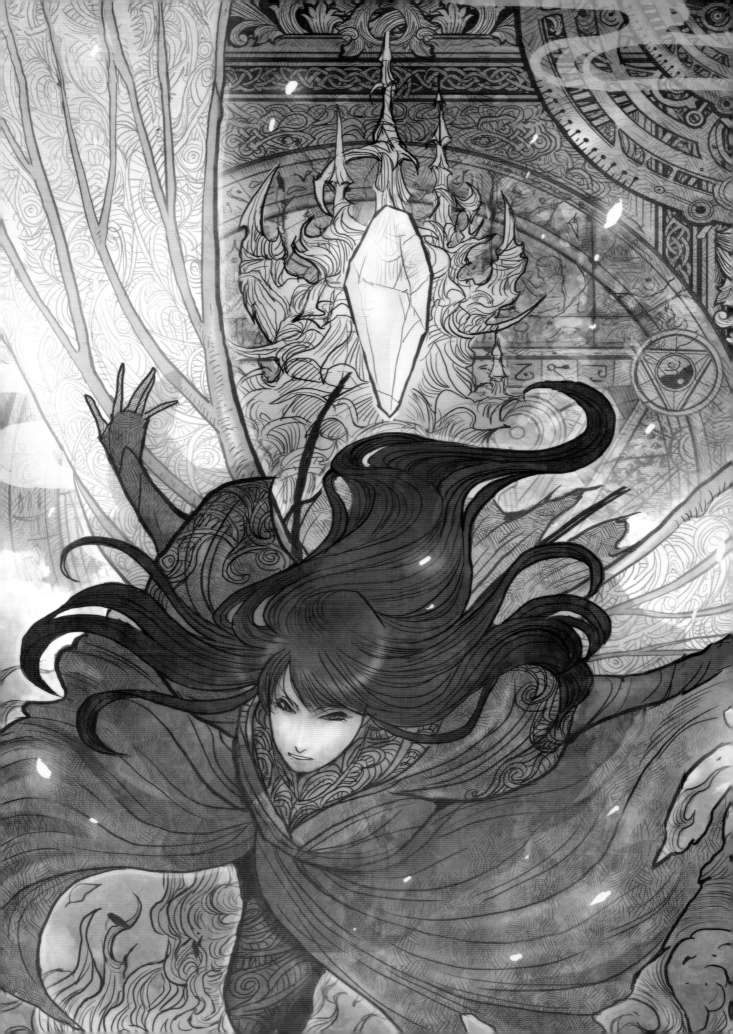

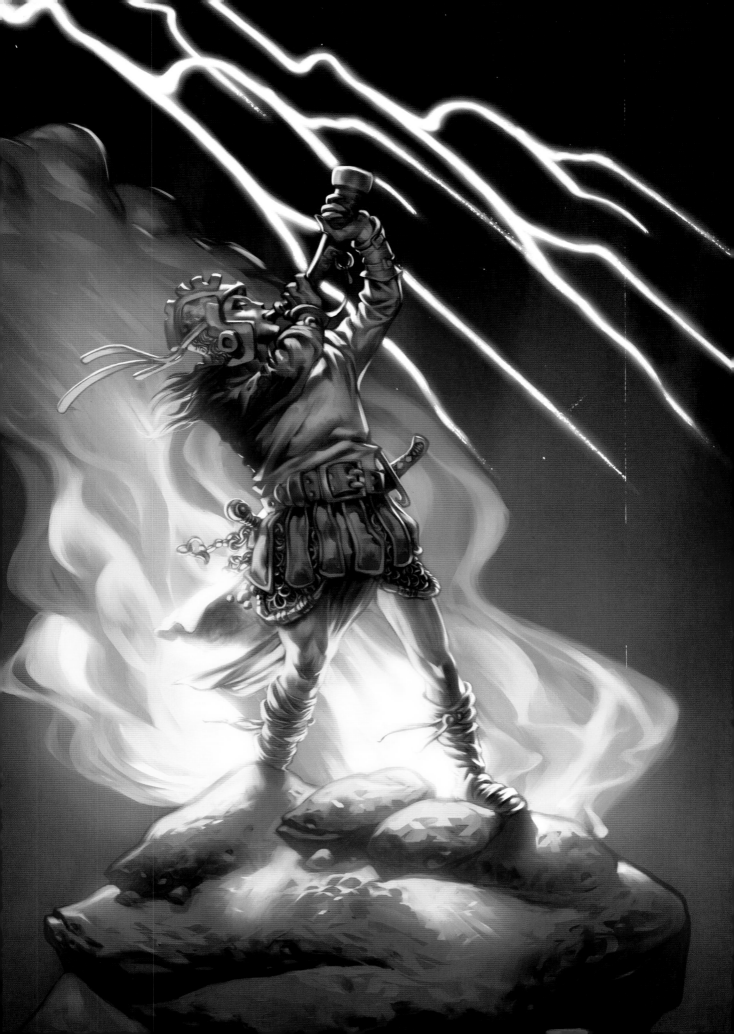

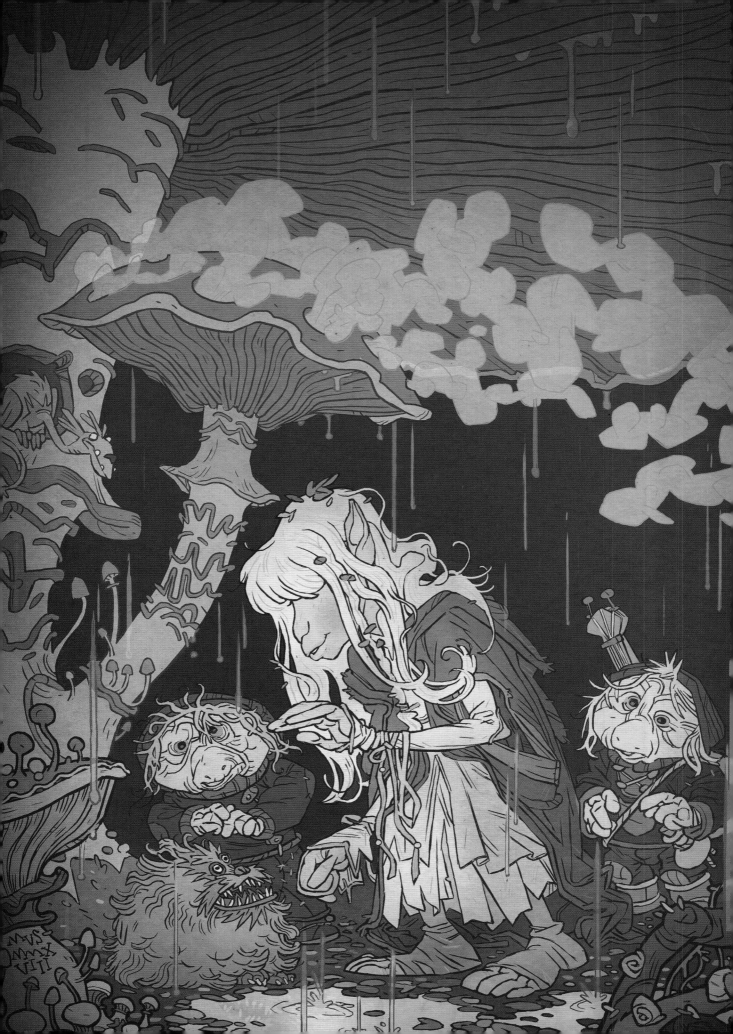

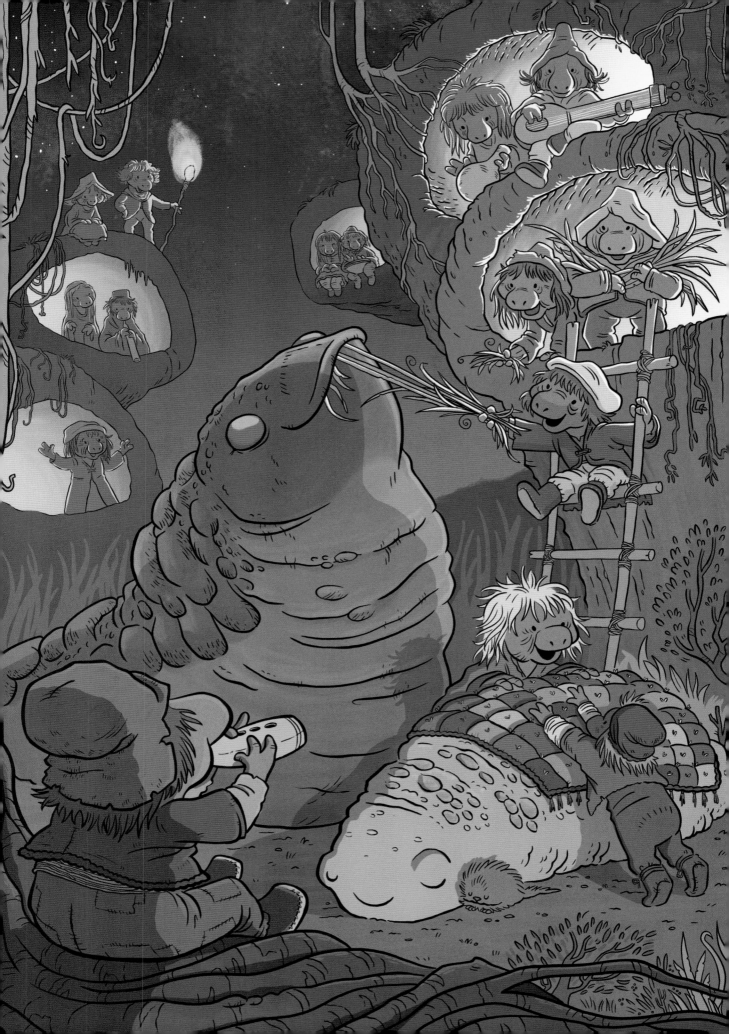

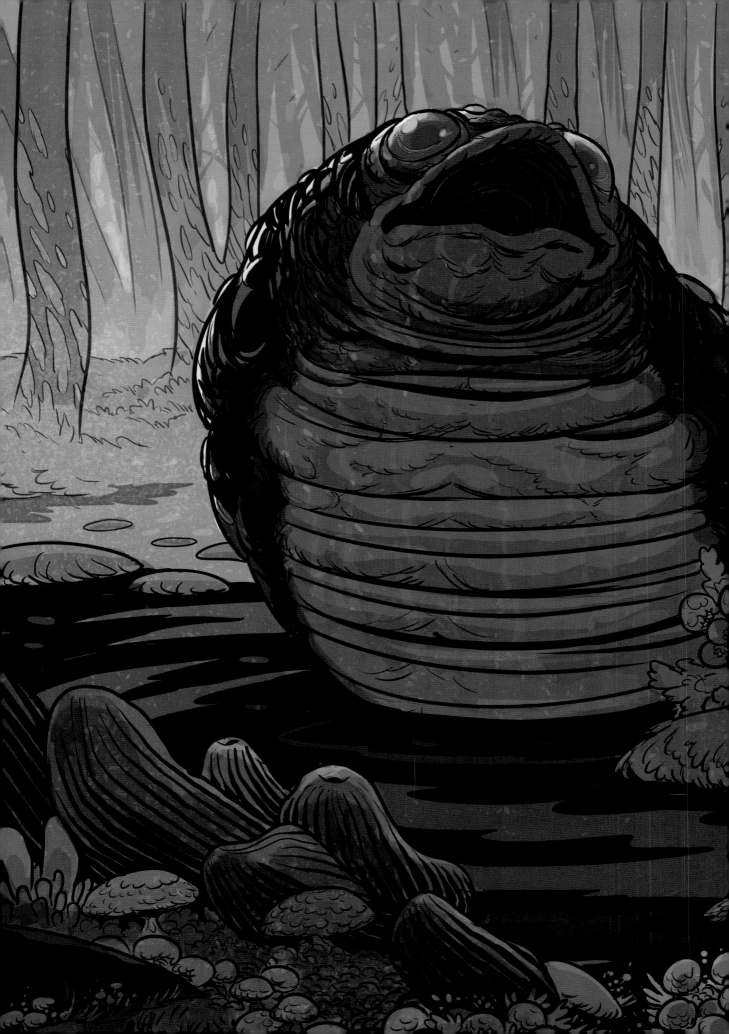

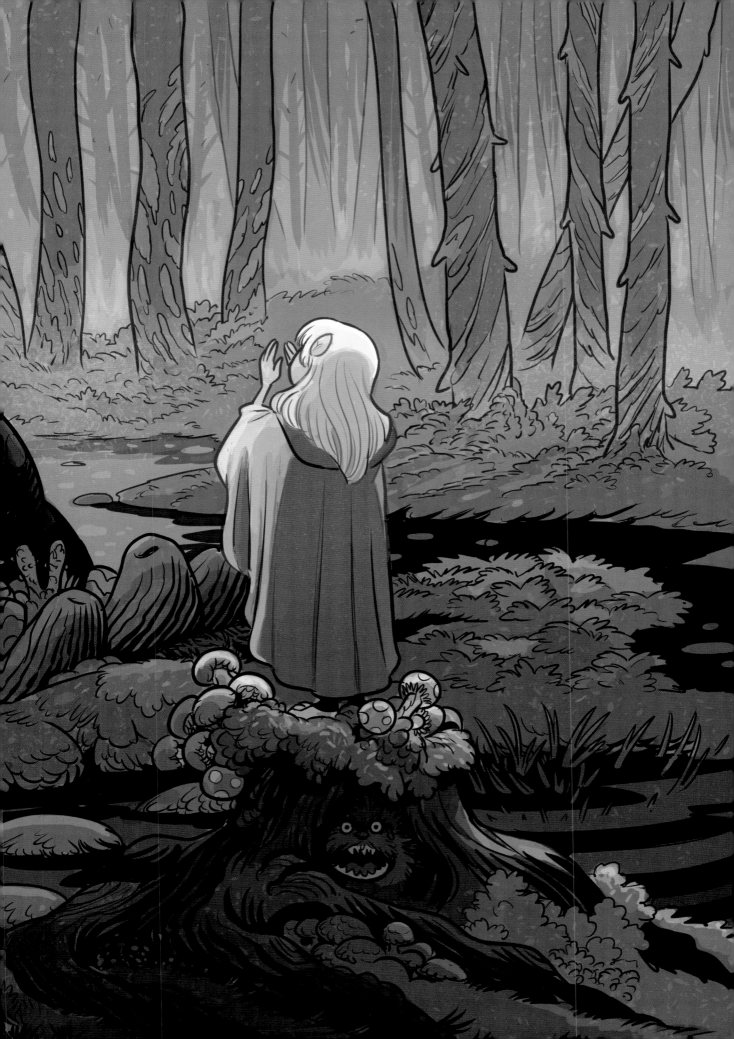

"End, begin, all the same. Big change.
Sometimes good. Sometimes bad."

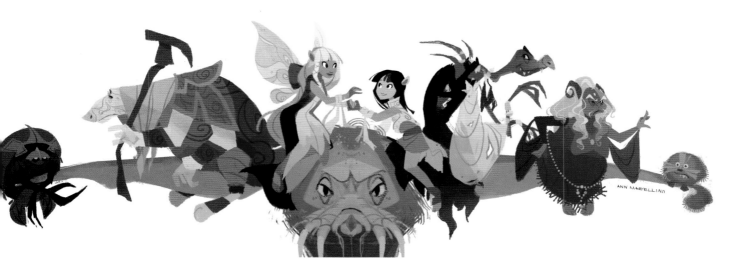

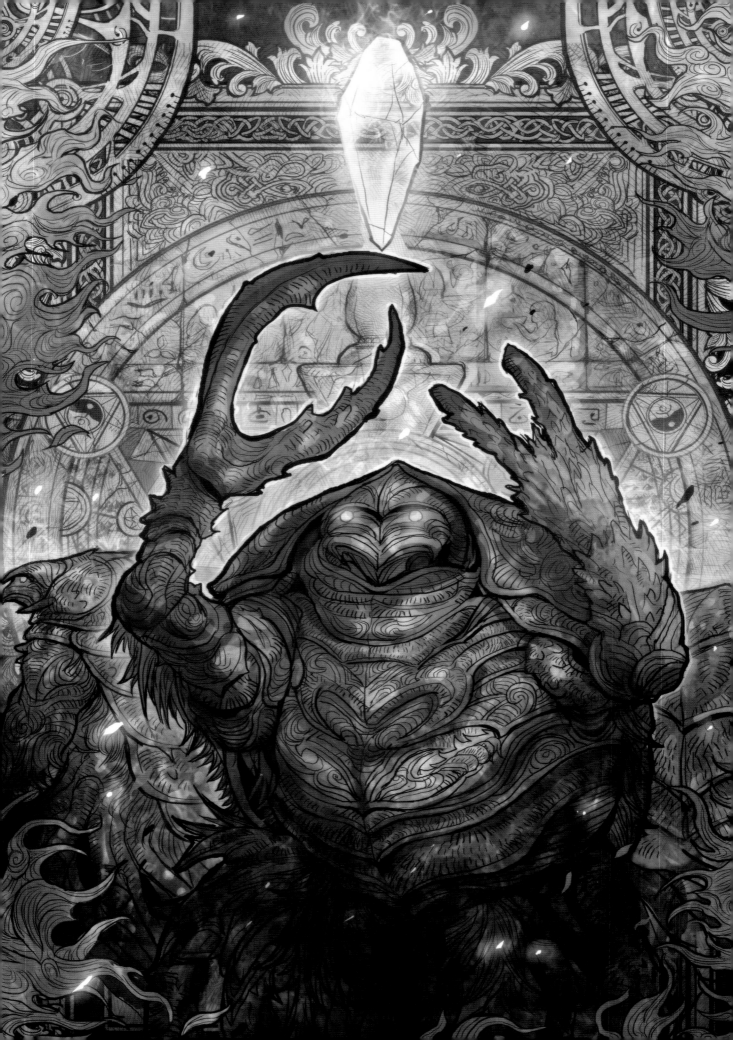

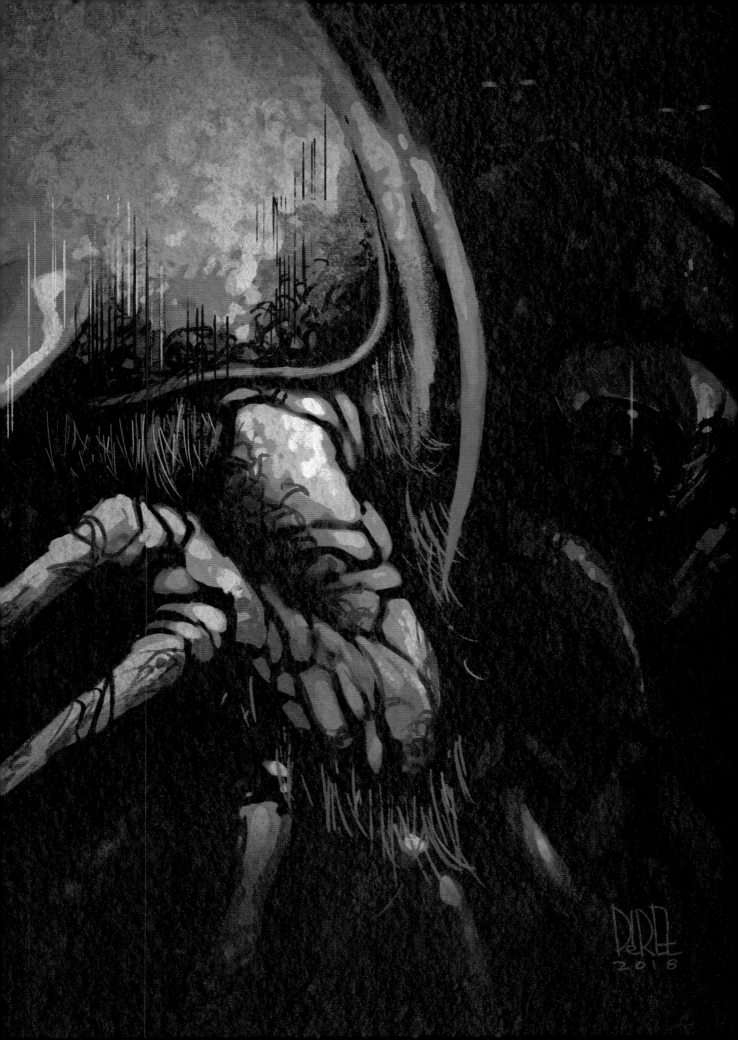

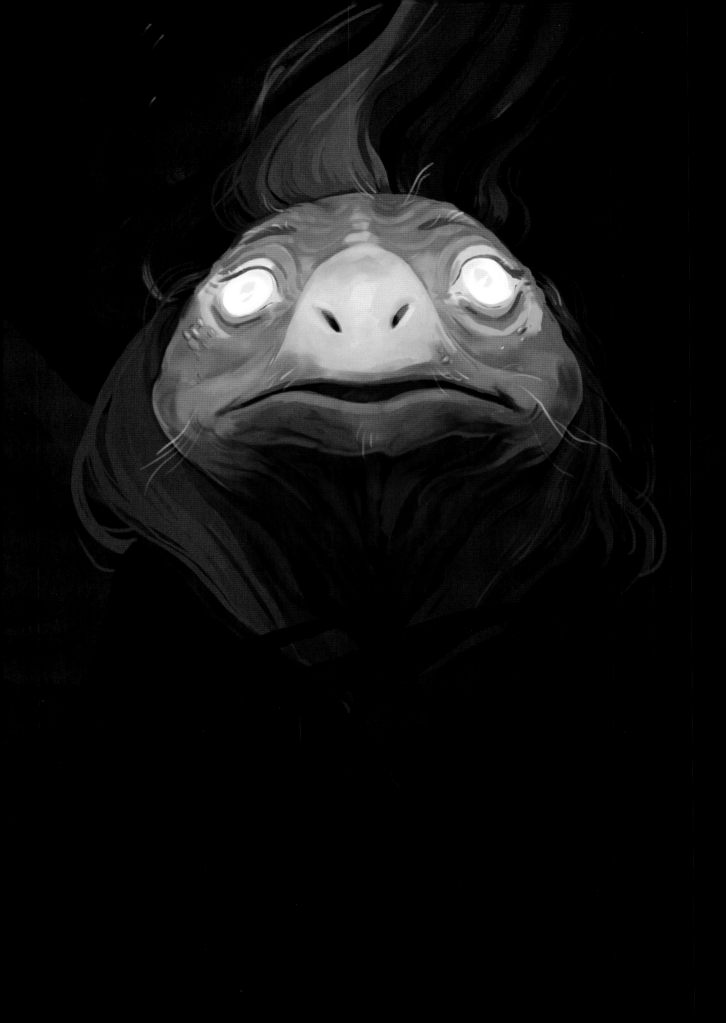

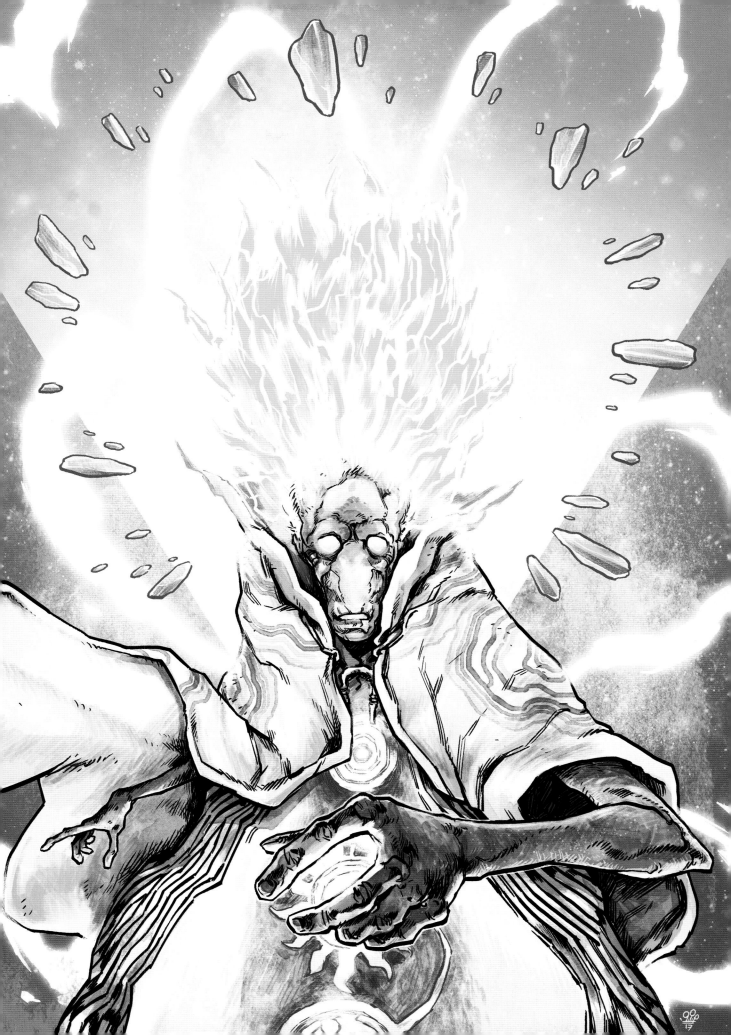

"The race of Mystics came to live in a dream of peace.
Their ways were the gentle ways of natural wizards."

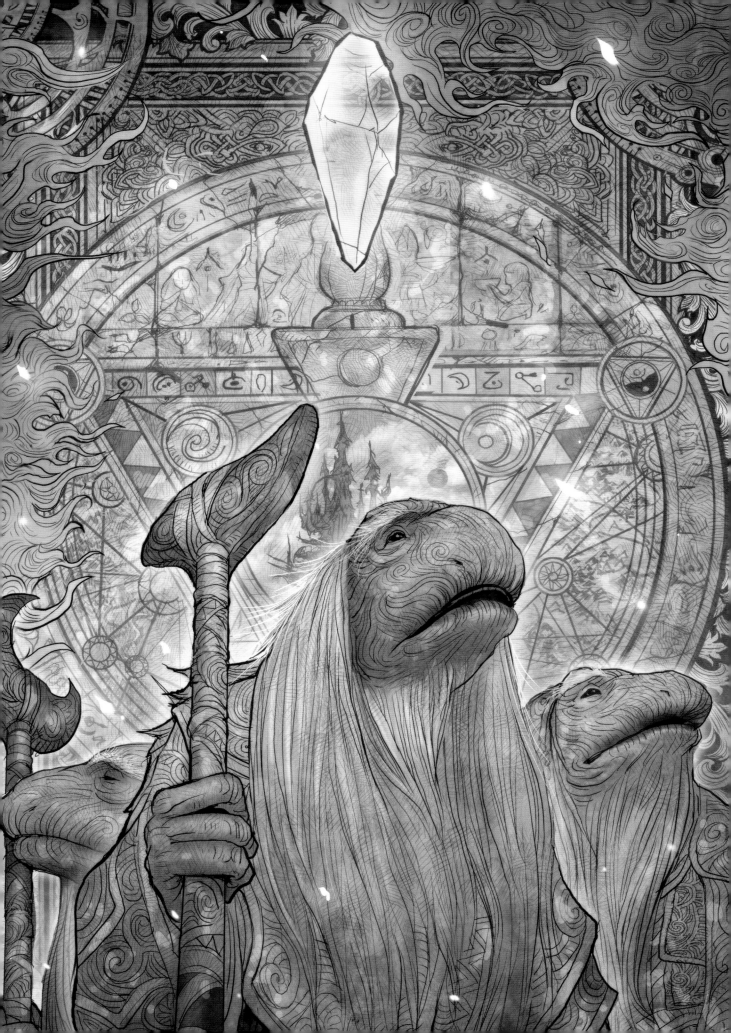

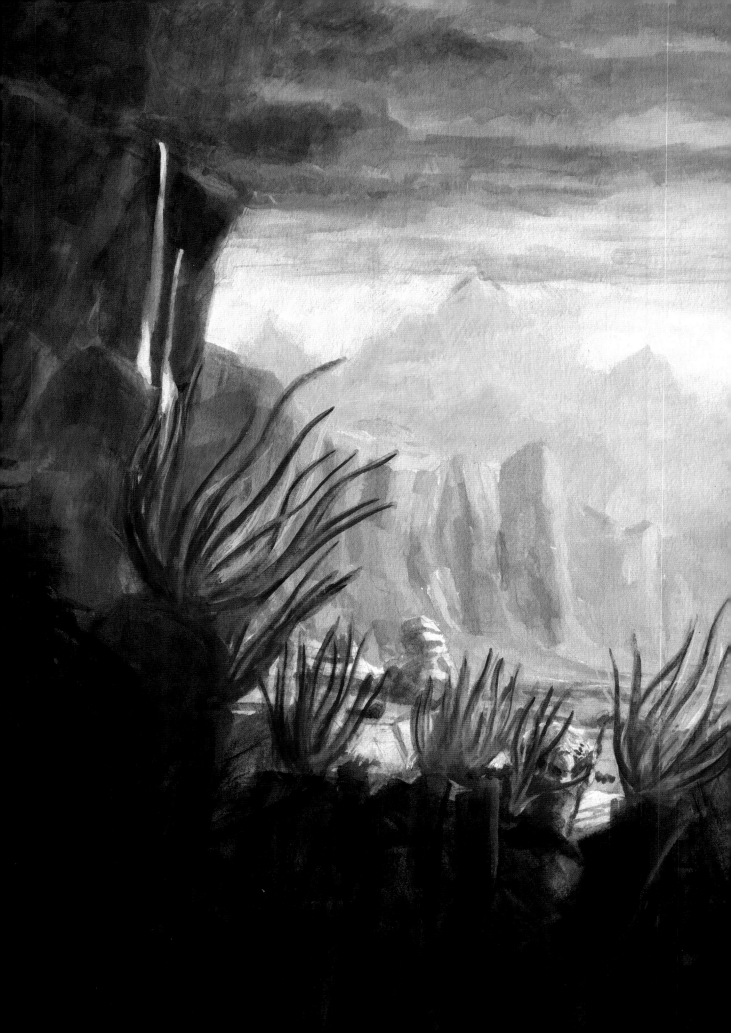

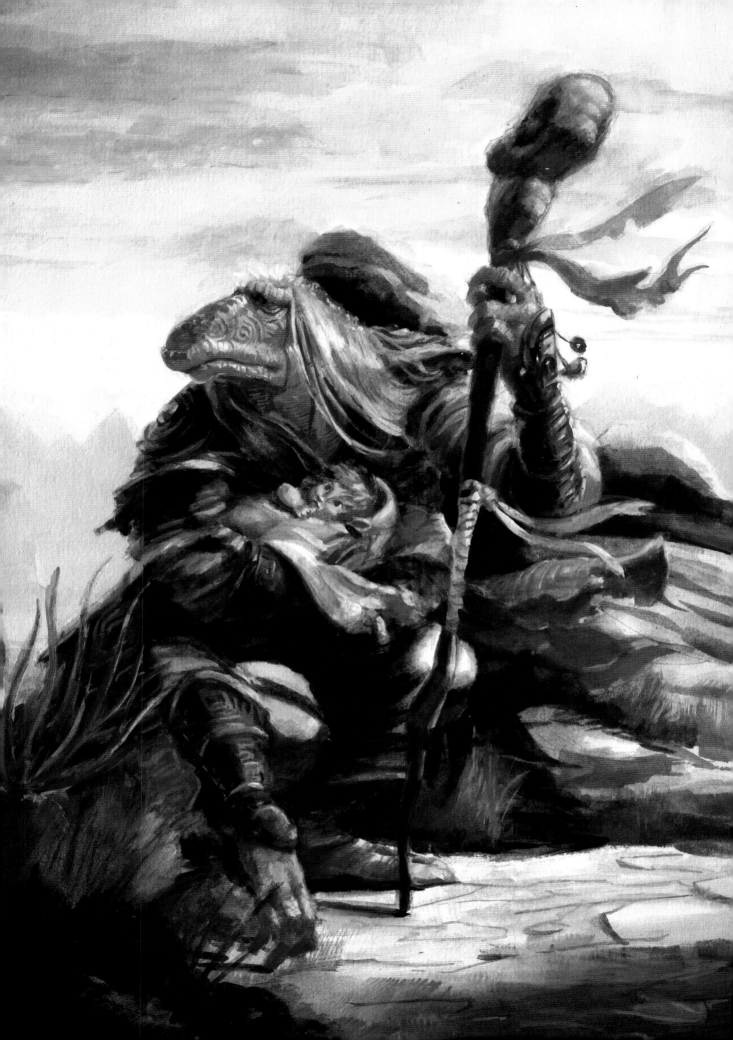

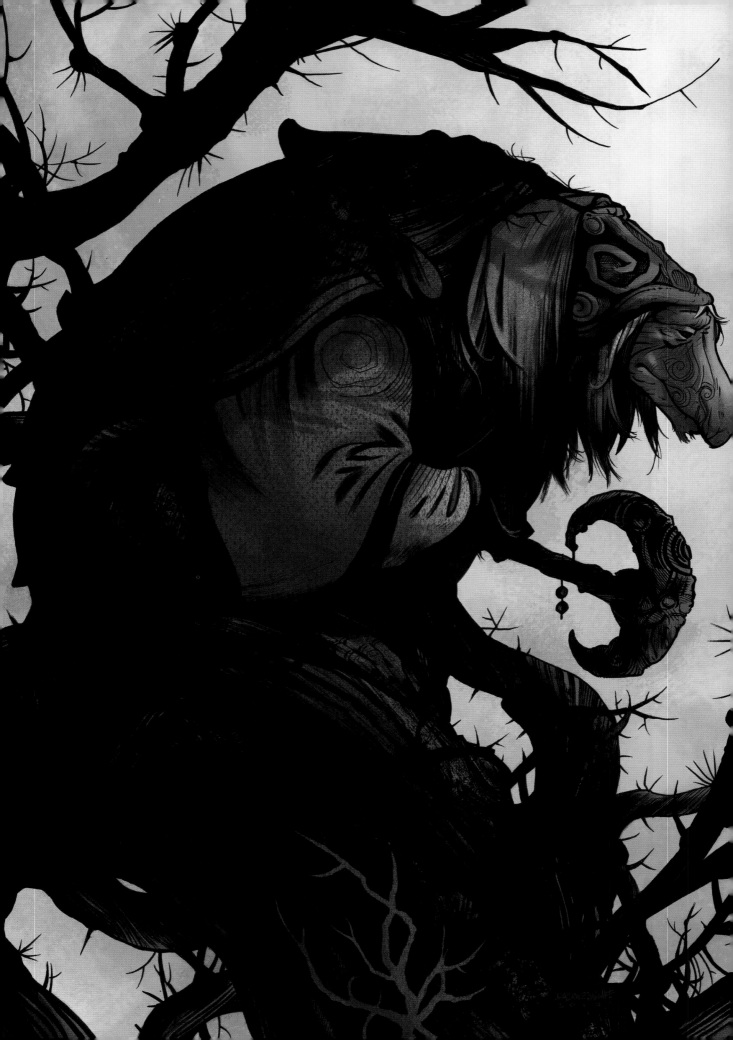

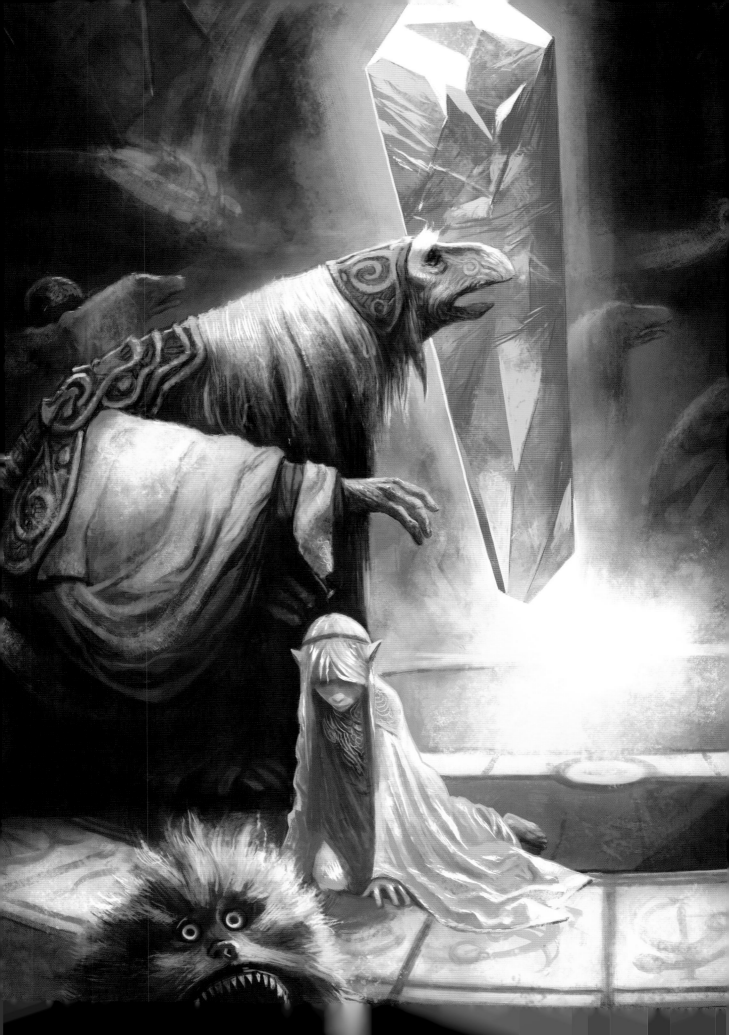

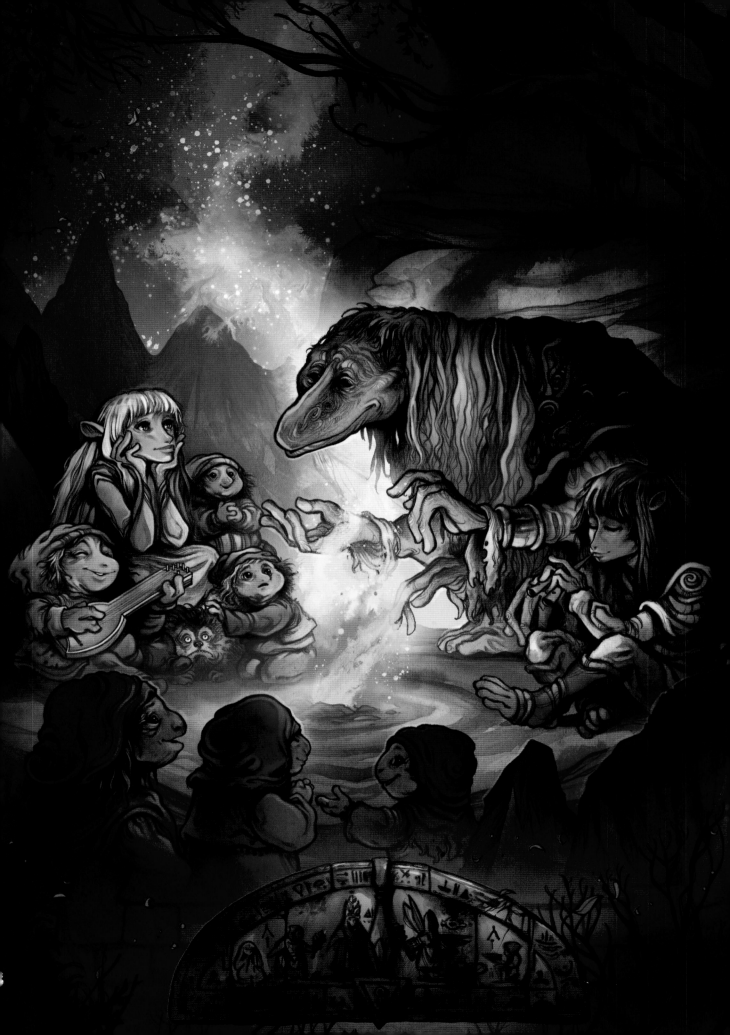

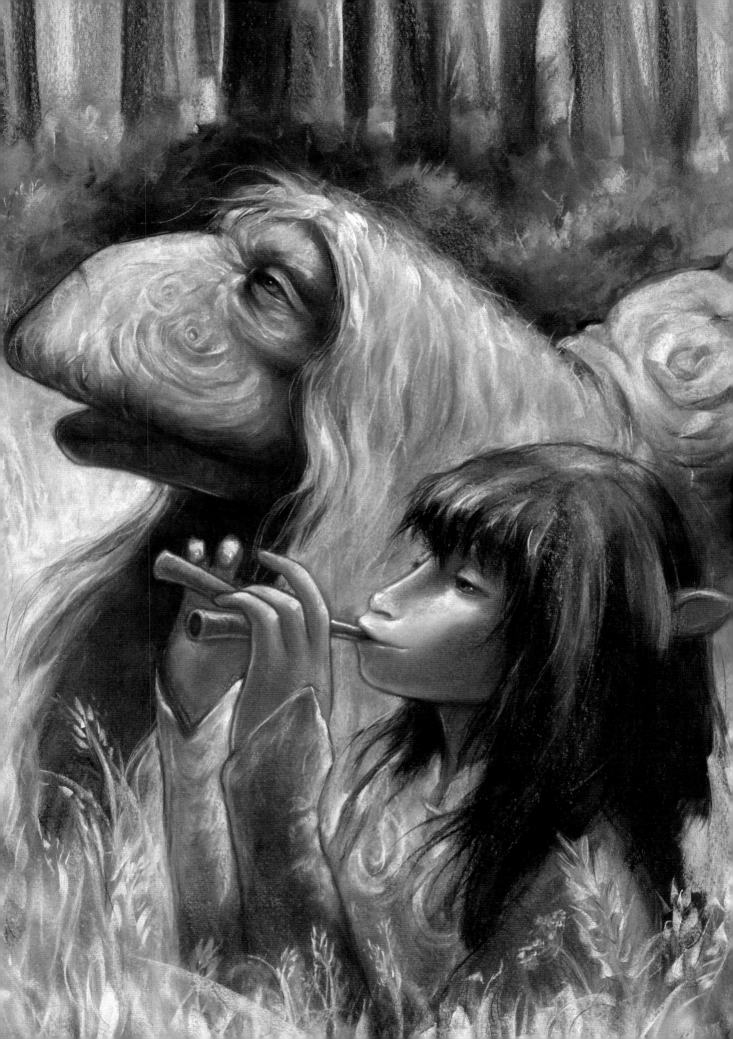

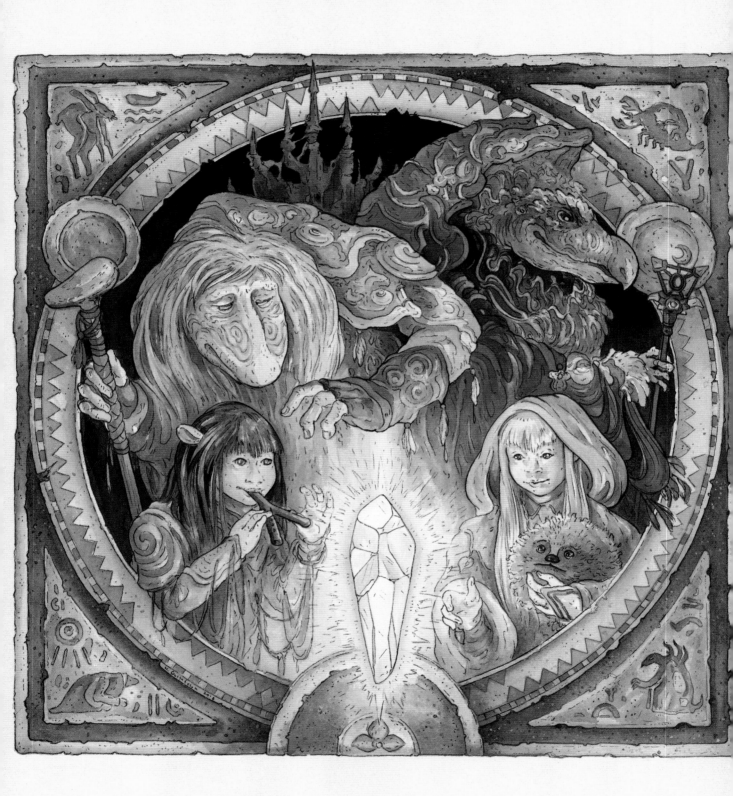

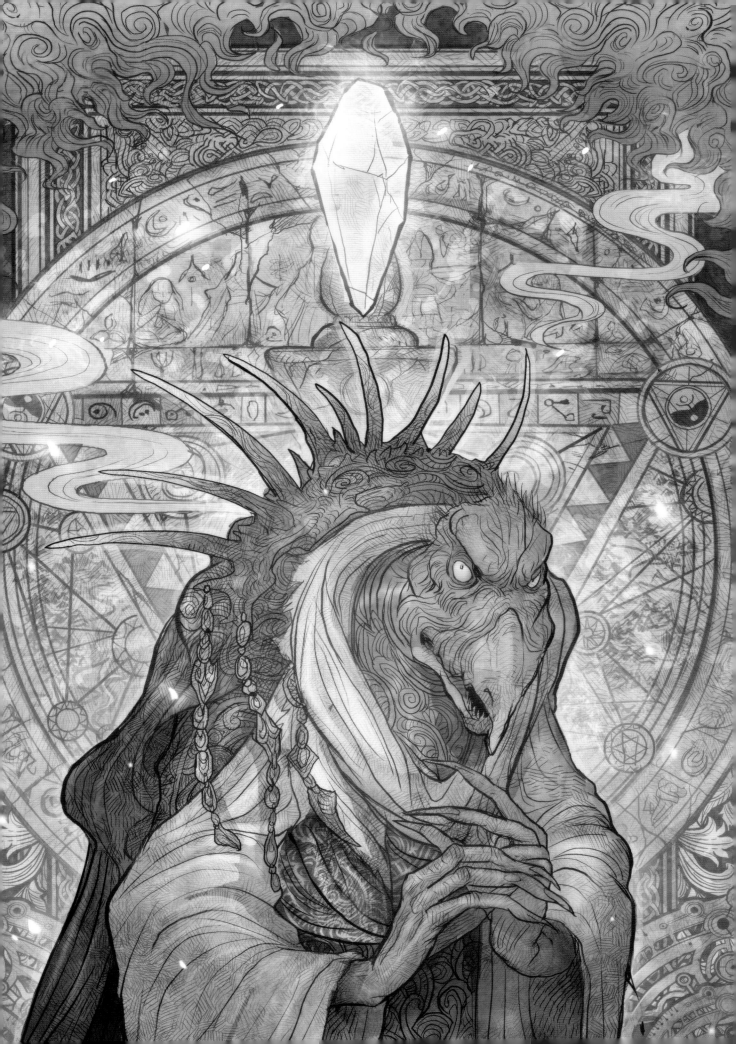

"To save our world, you must find the shard before the three suns meet. If not, Skeksis rule forever."

Page 54: *Art by Cory Godbey*. Page 55: *Art by Ashly Lovett*. Previous Pages: *Art by Nicole Gustafsson* (left) and *art by Sana Takeda* (right). Facing Page: *Art by Lee Garbett*. Following Pages: *Art by Ian Herring*. Pages 62-66: *Art by Mac Smith*.

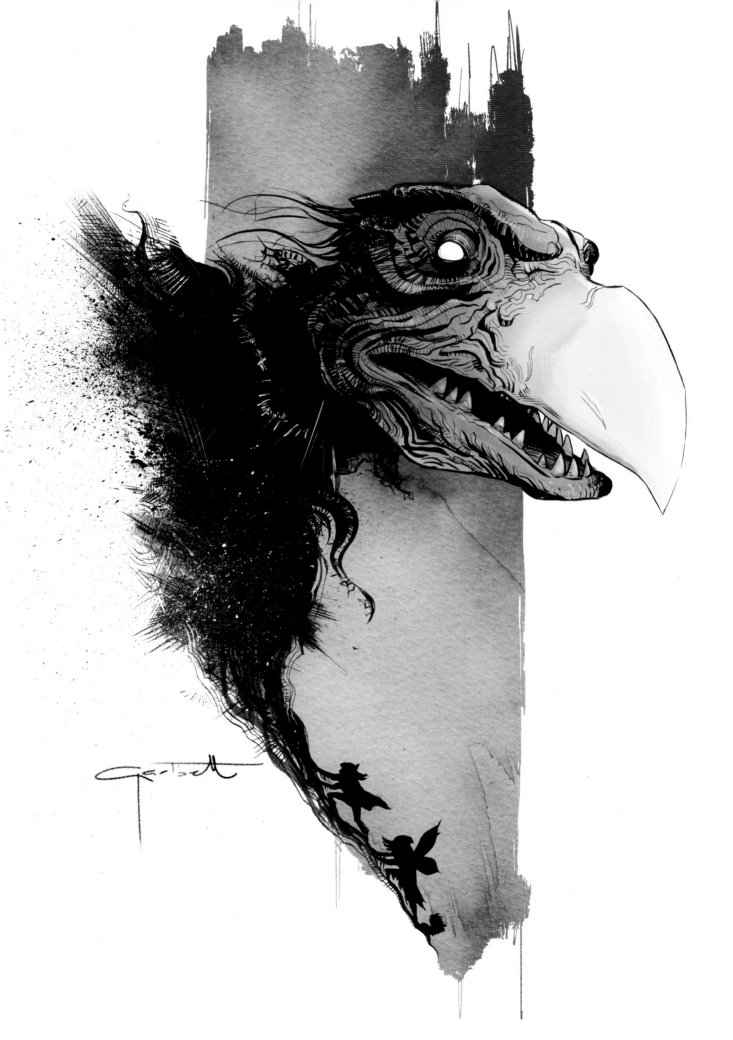

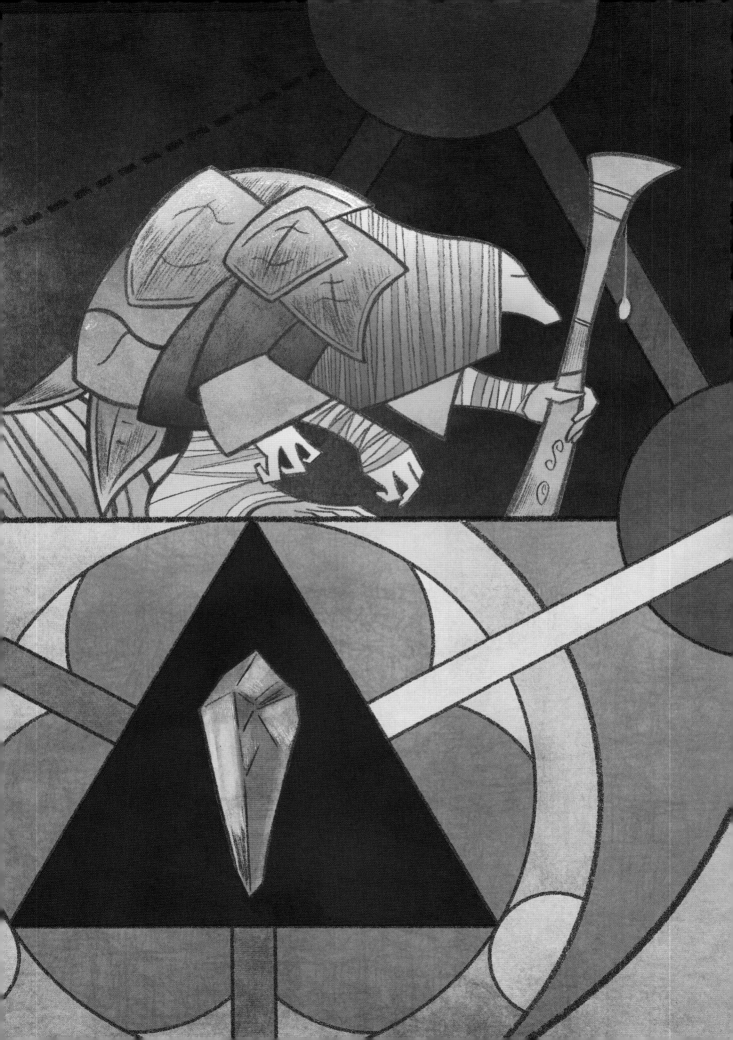

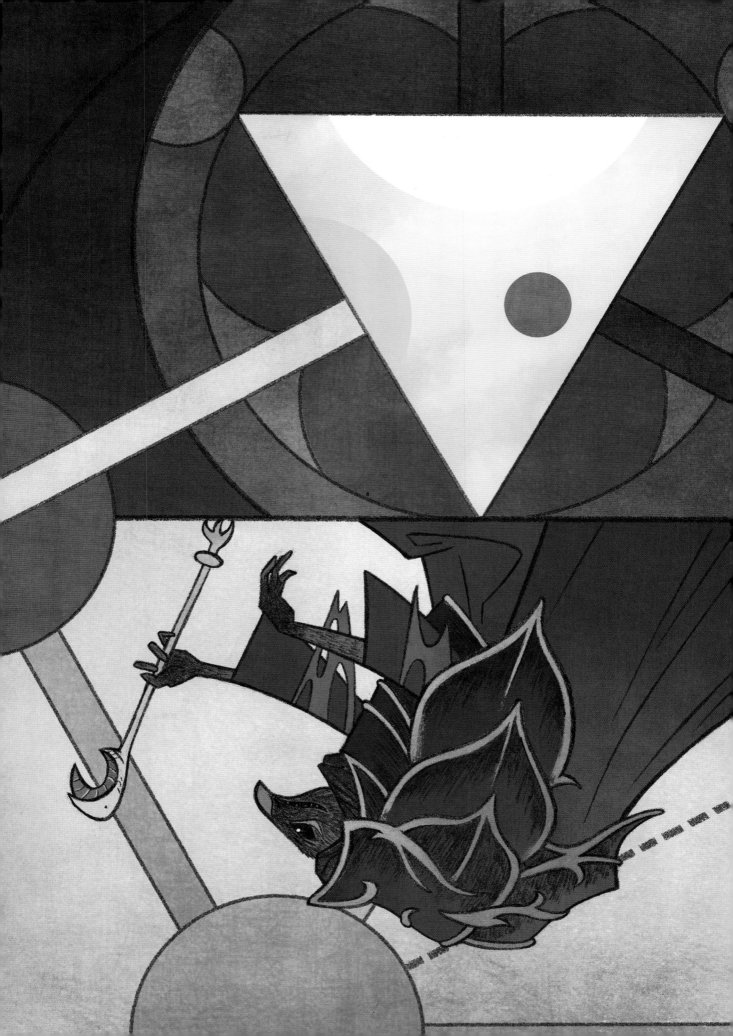

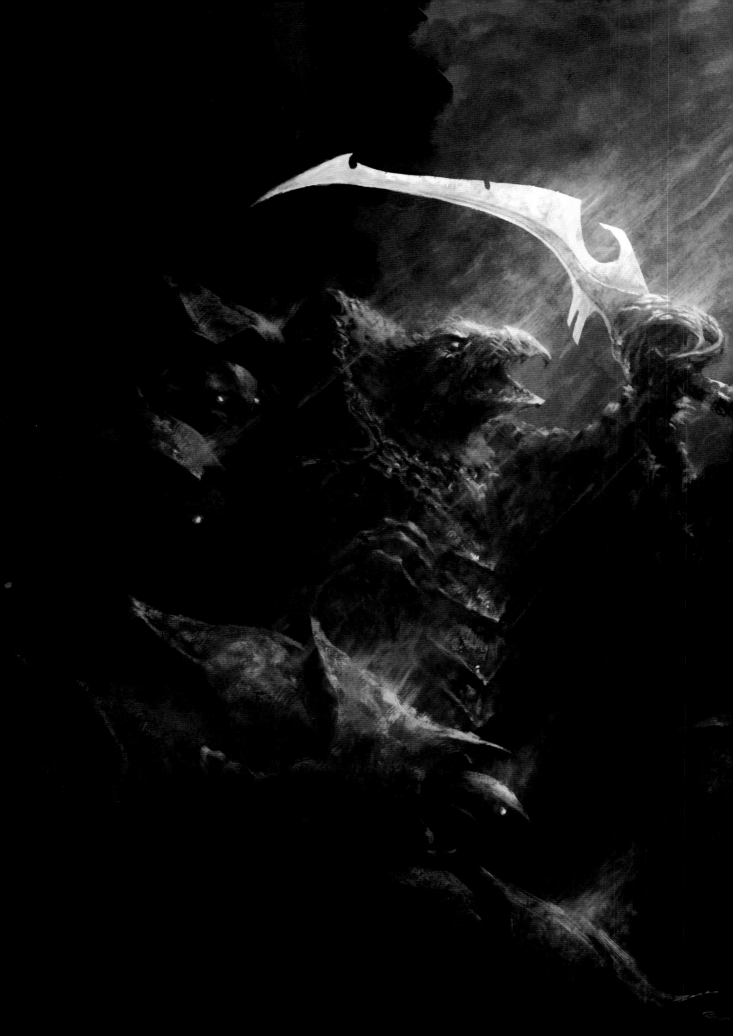

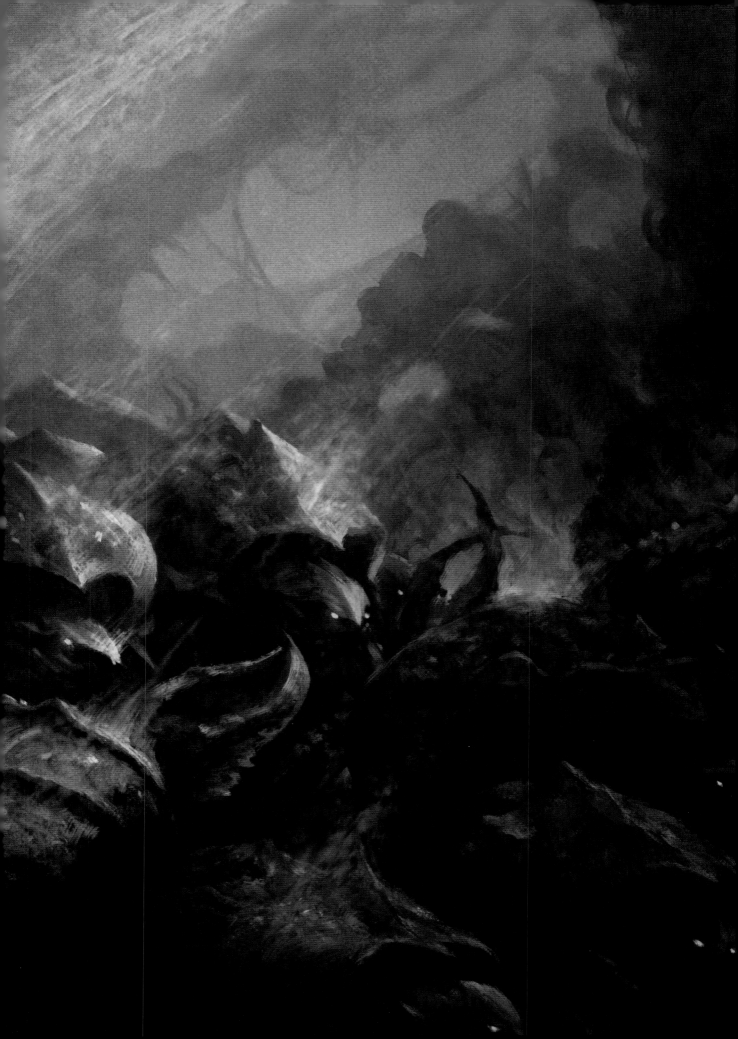

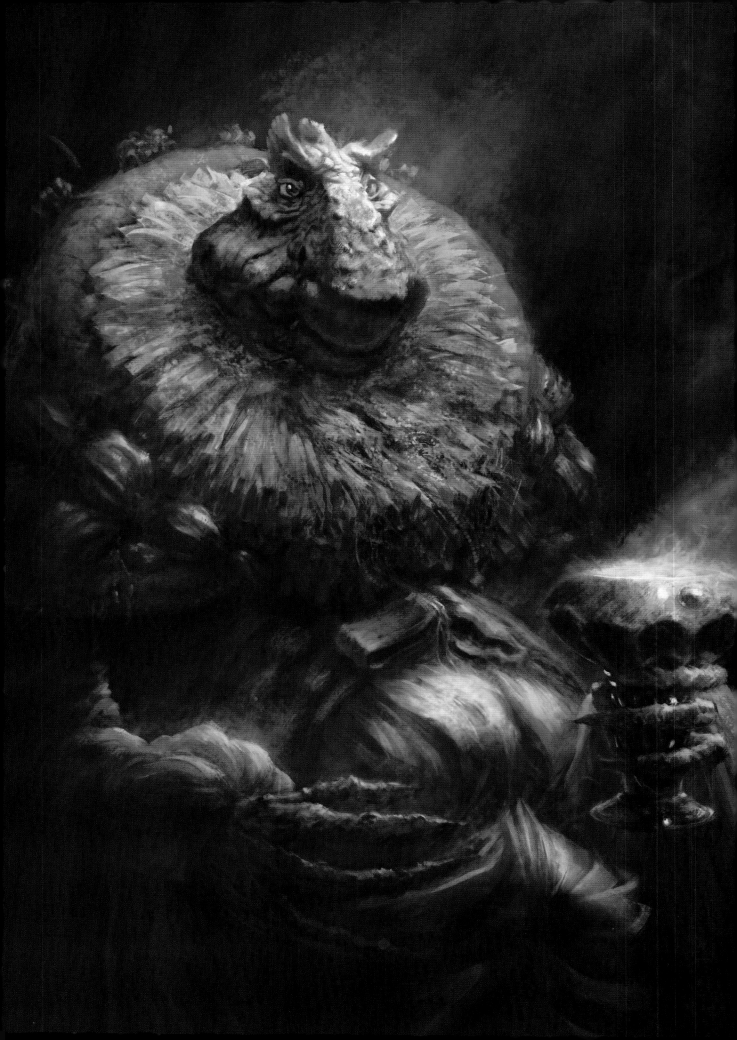

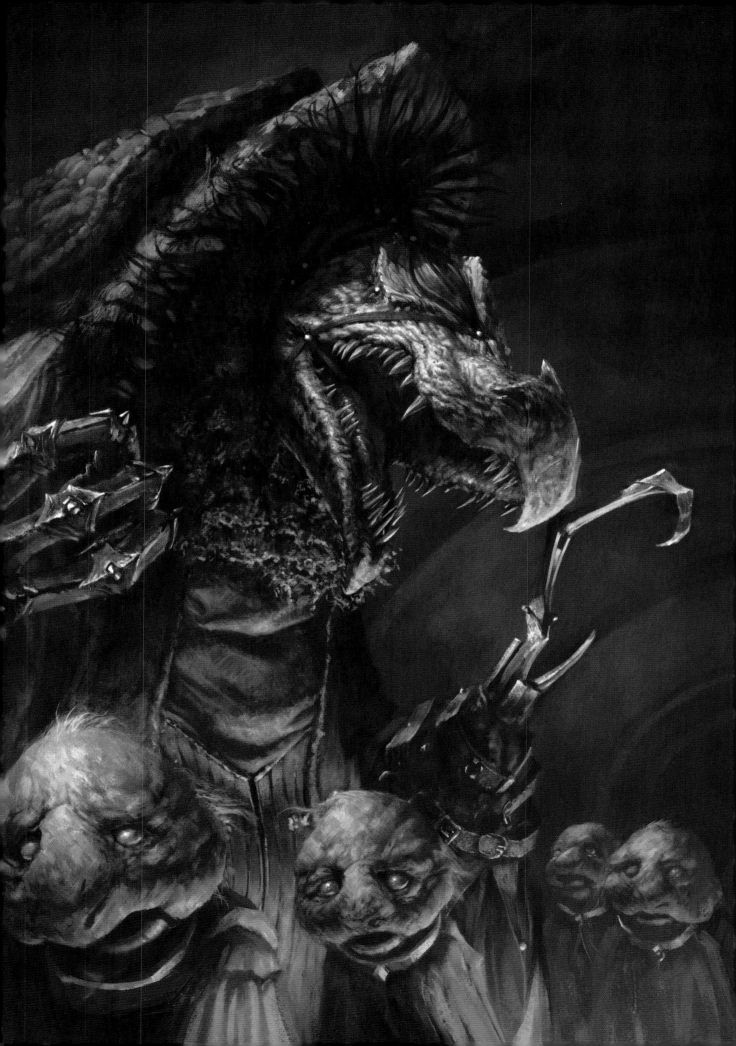

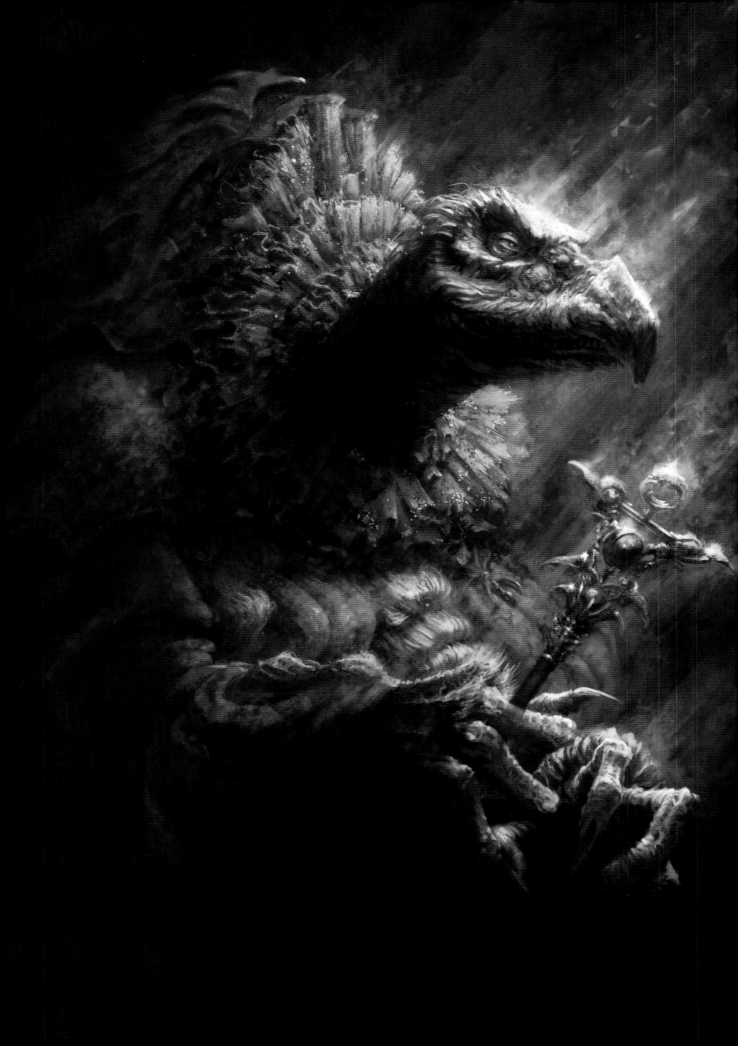

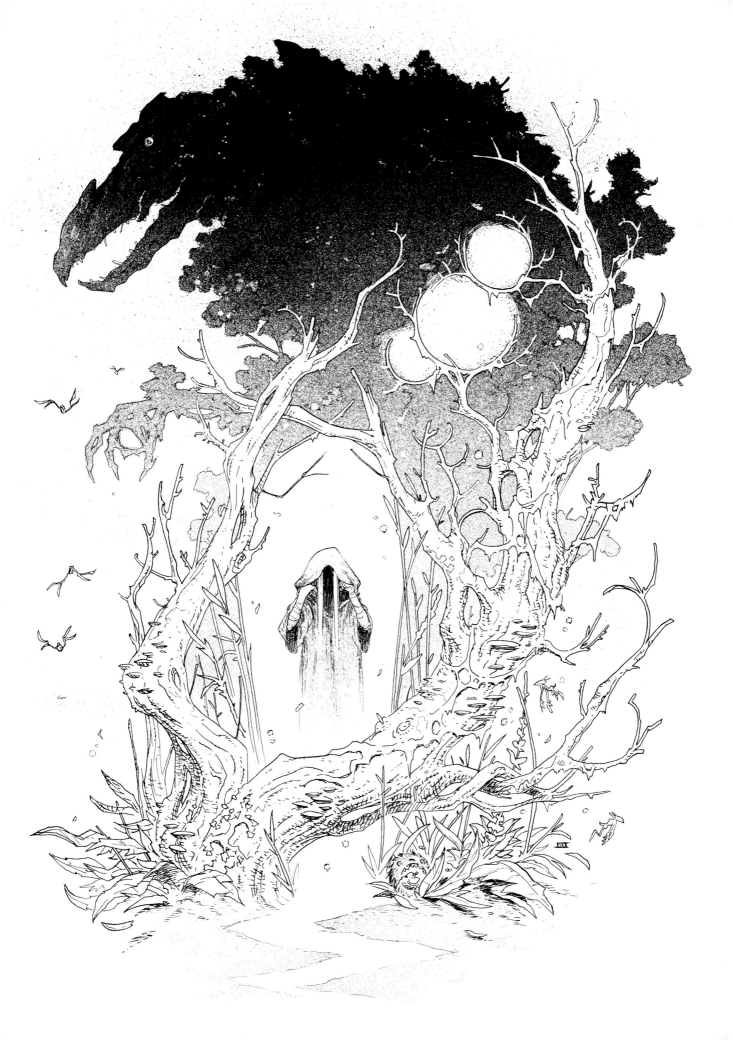

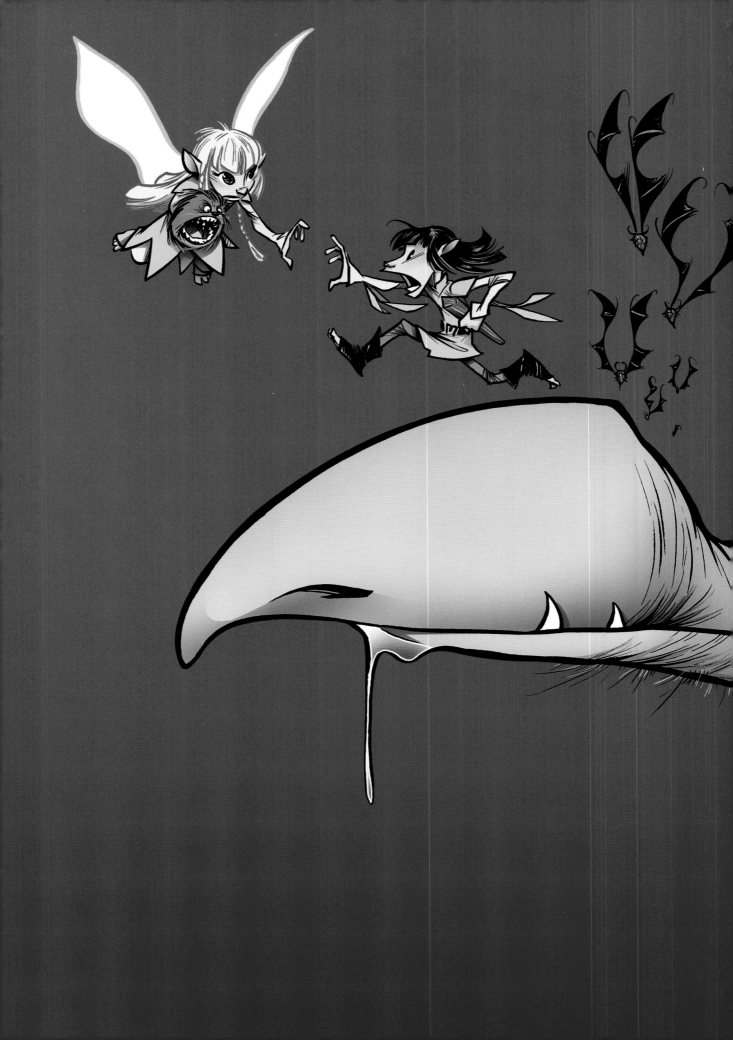

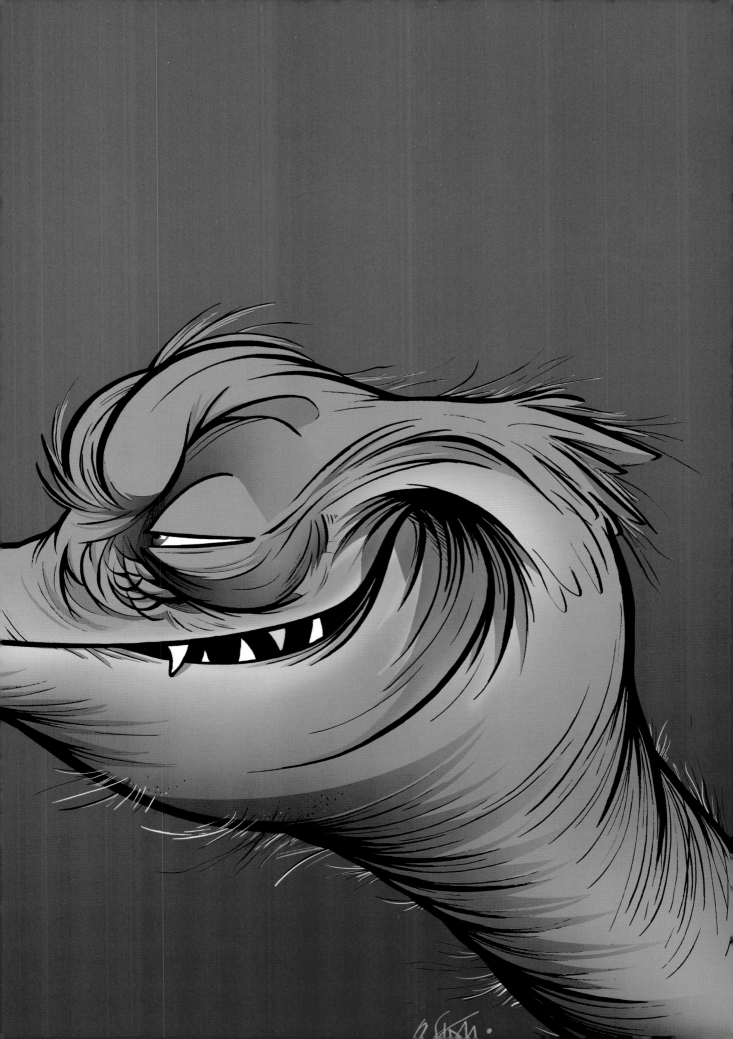

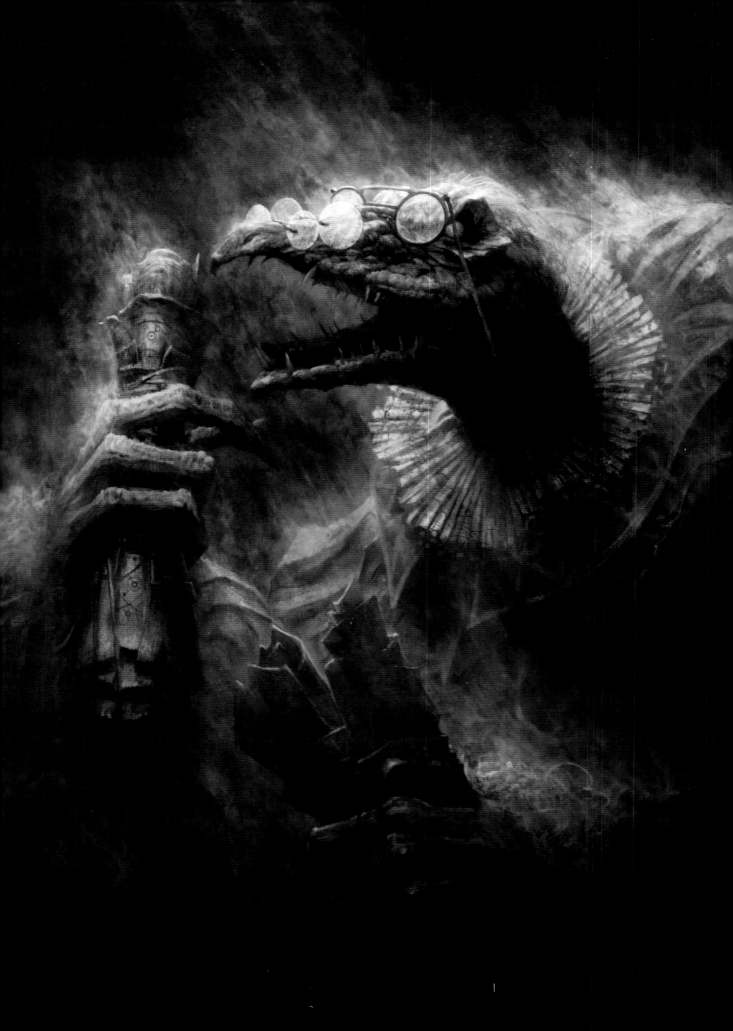

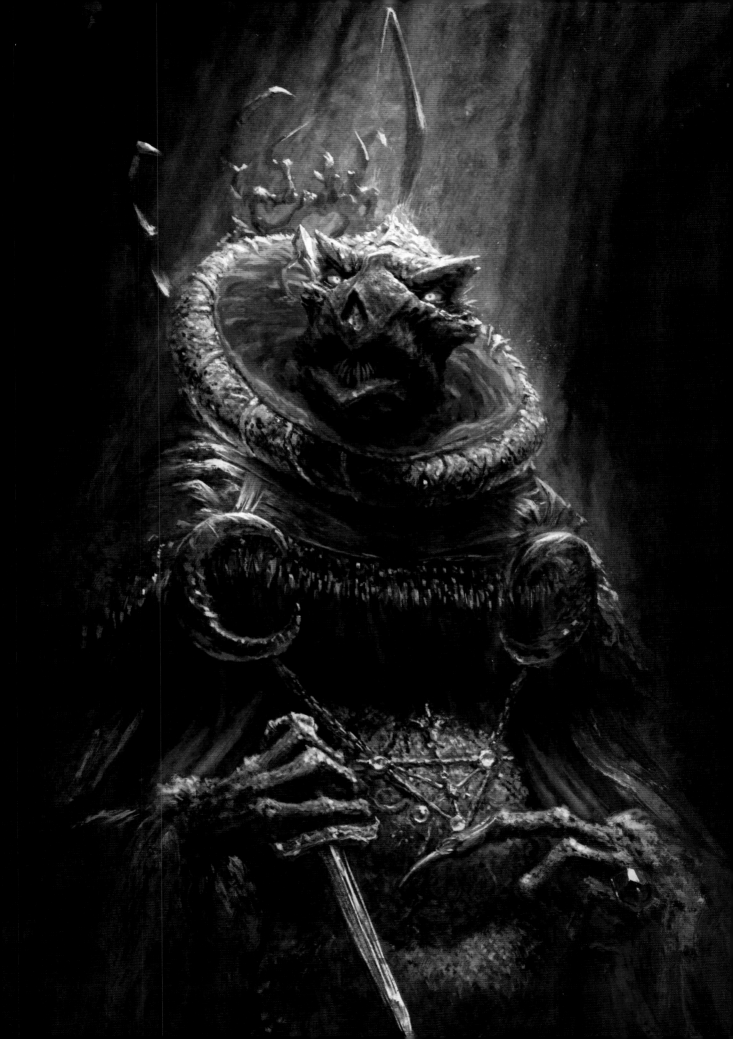

"The Skeksis, with their hard and
twisted bodies, their harsh and twisted wills.
For a thousand years they have ruled…"

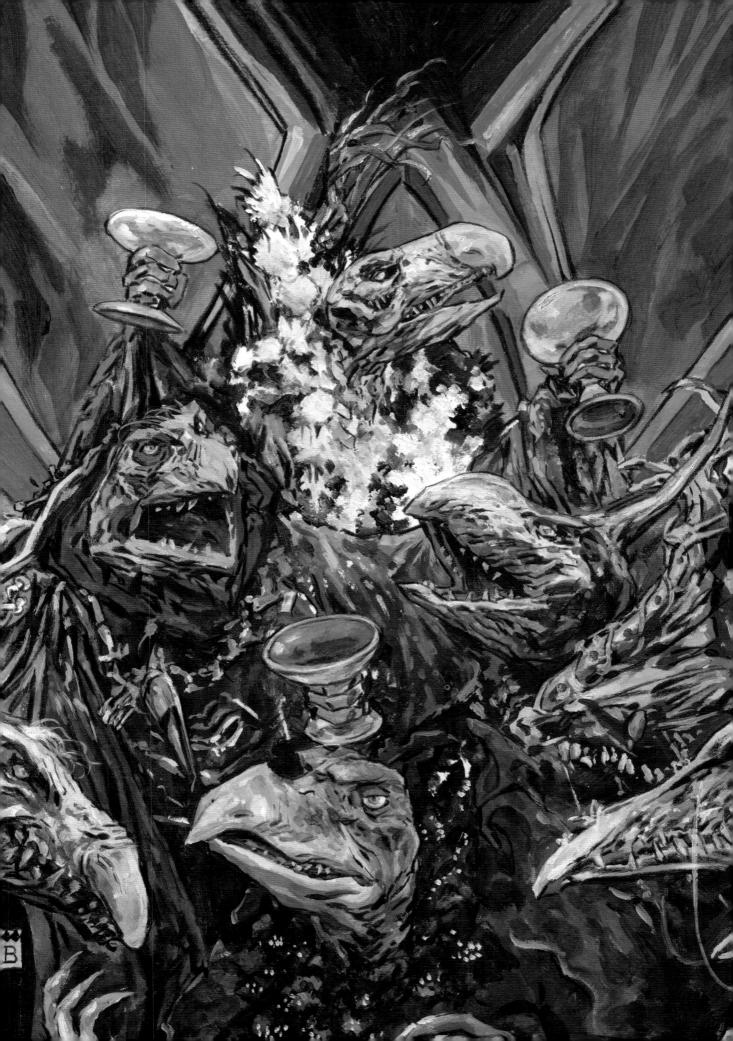

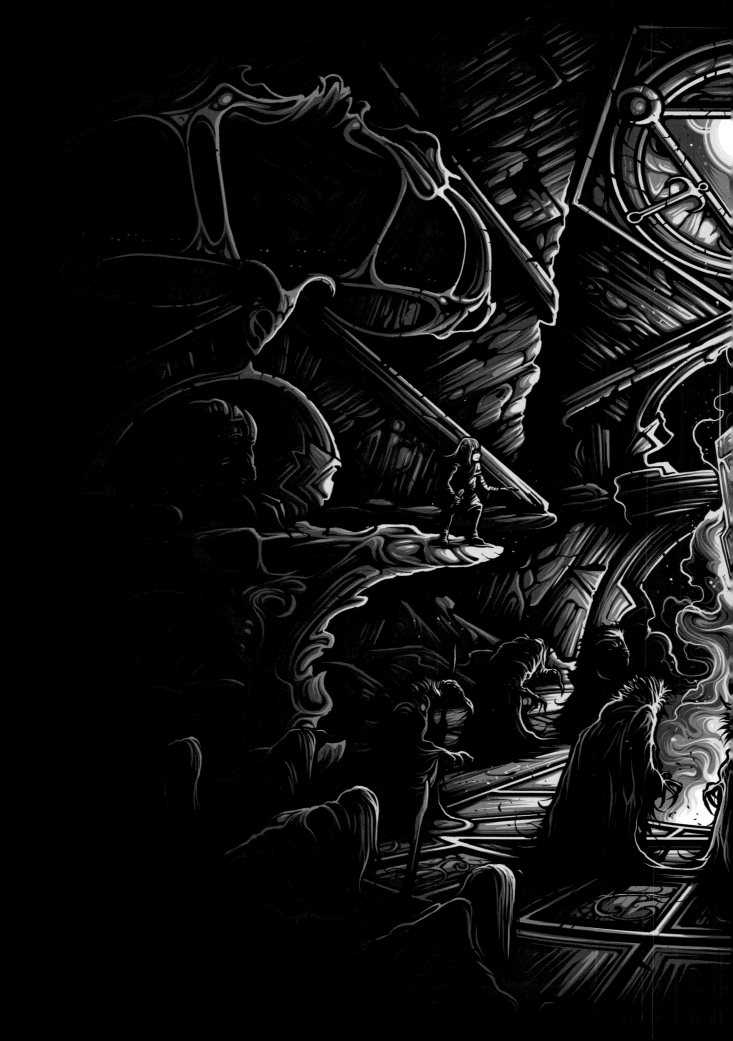

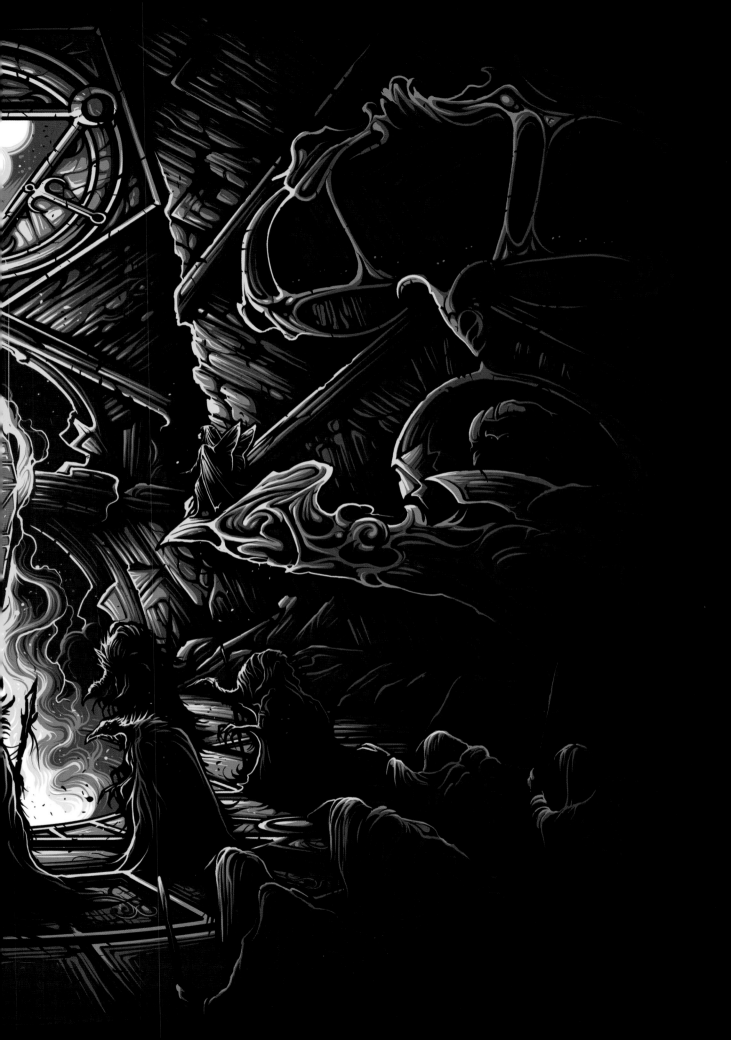

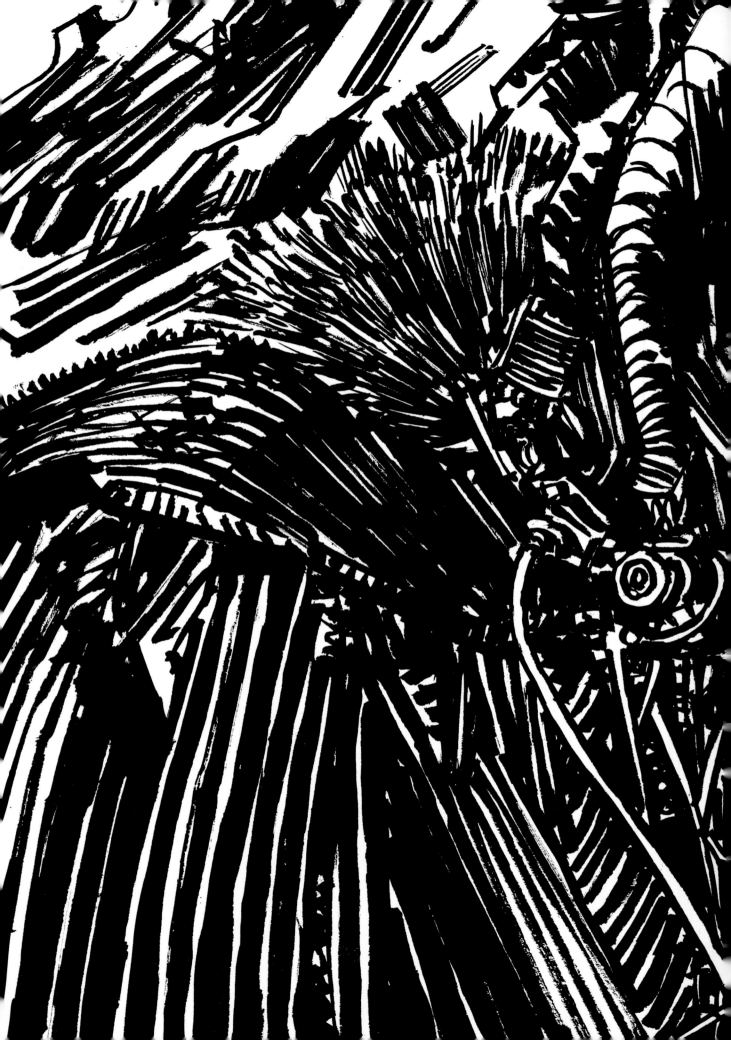

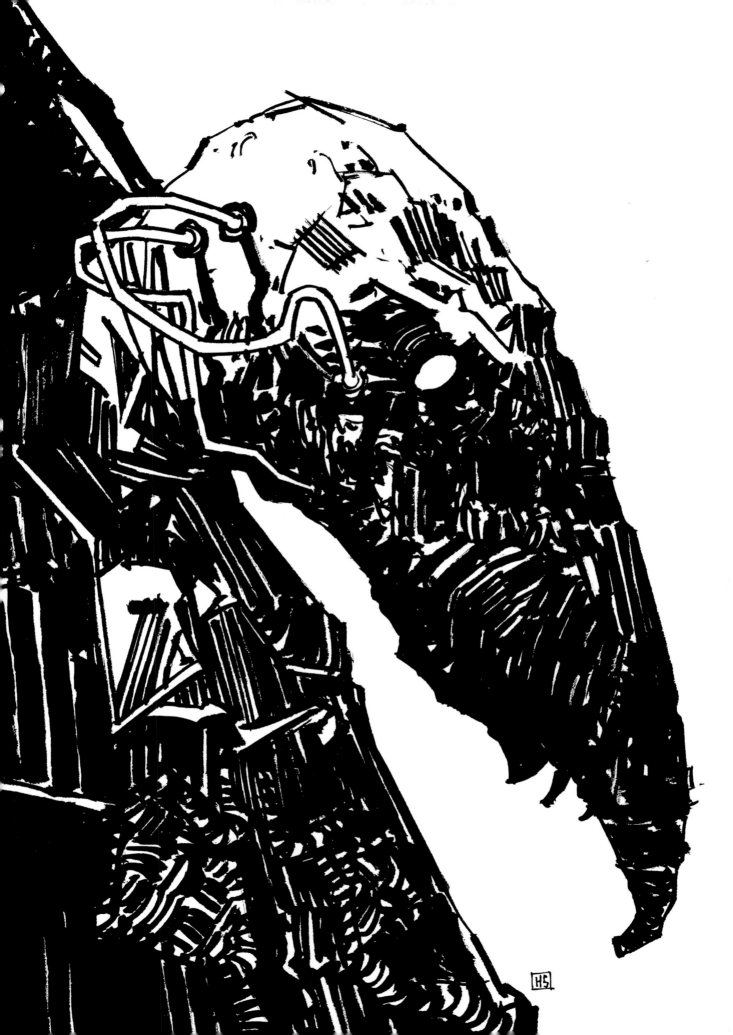

**"Now we leave you the Crystal of Truth.
Make your world in its light."**

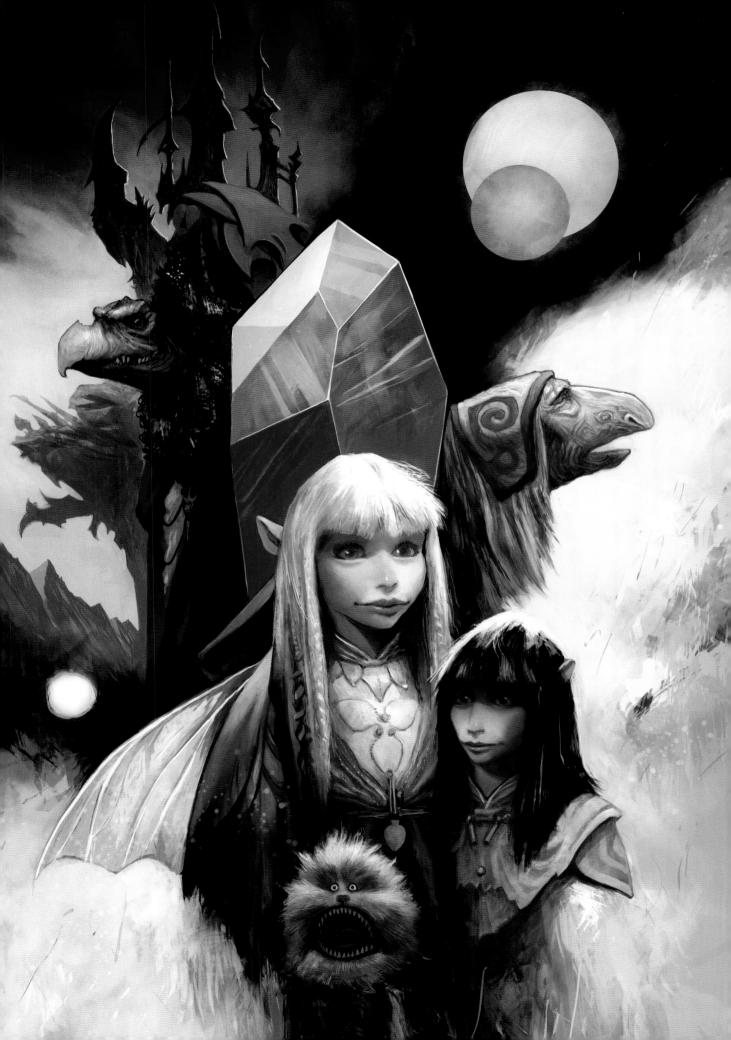

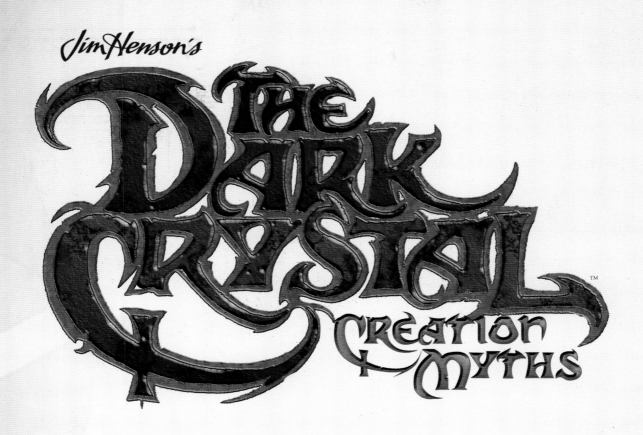

Jim Henson's

THE DARK CRYSTAL
Creation Myths

™

An official prequel to the original film,
The Dark Crystal: Creation Myths graphic novel series was
conceptualized by Brian Froud and includes all new characters,
including the introduction of Aughra's son, Raunip.

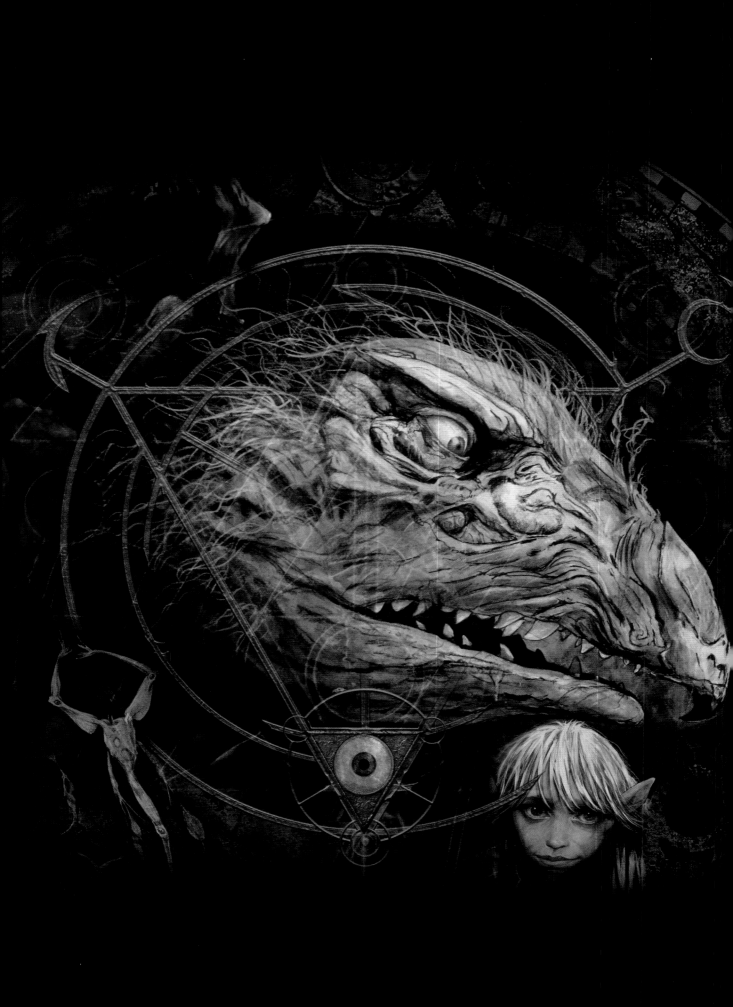

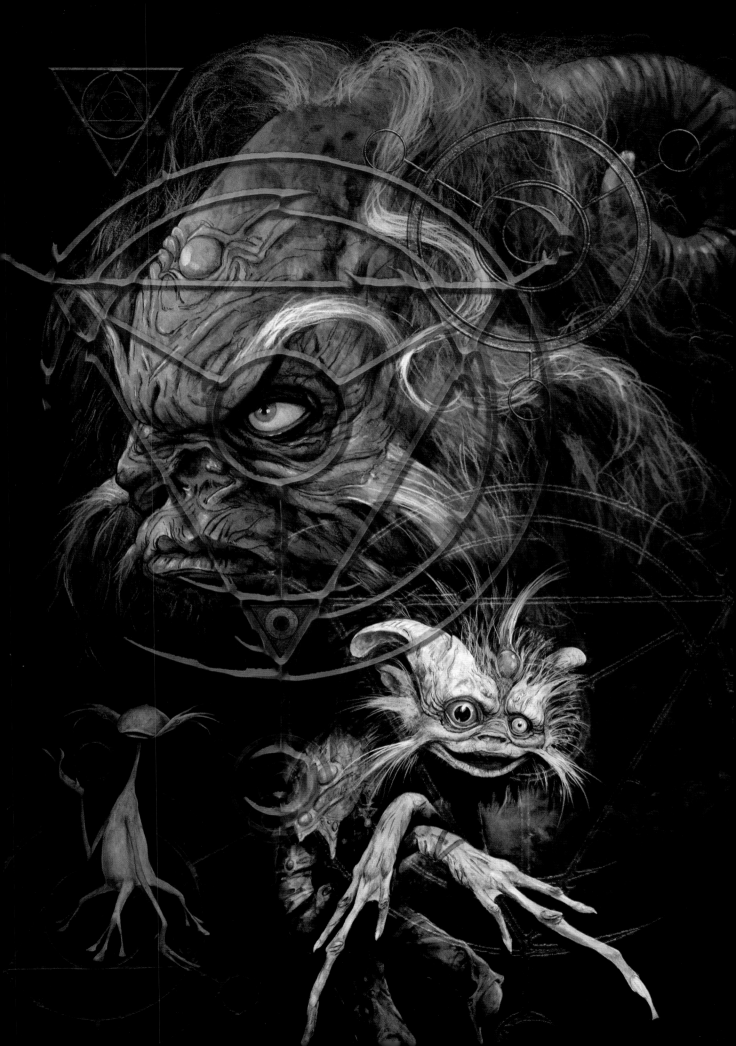

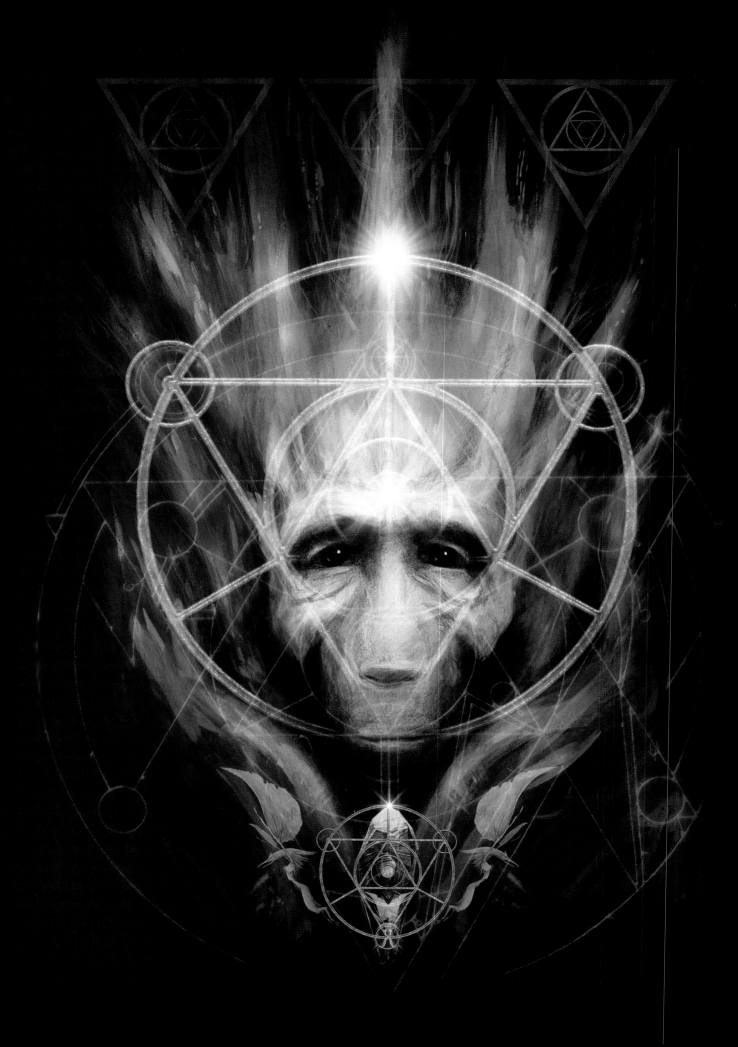

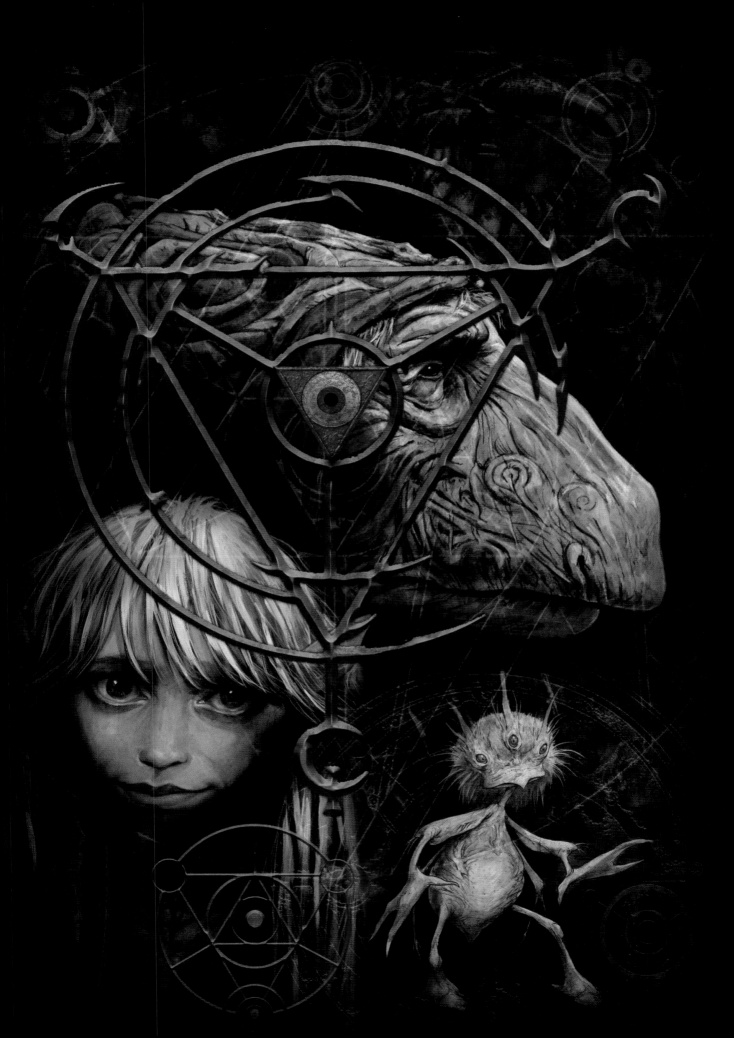

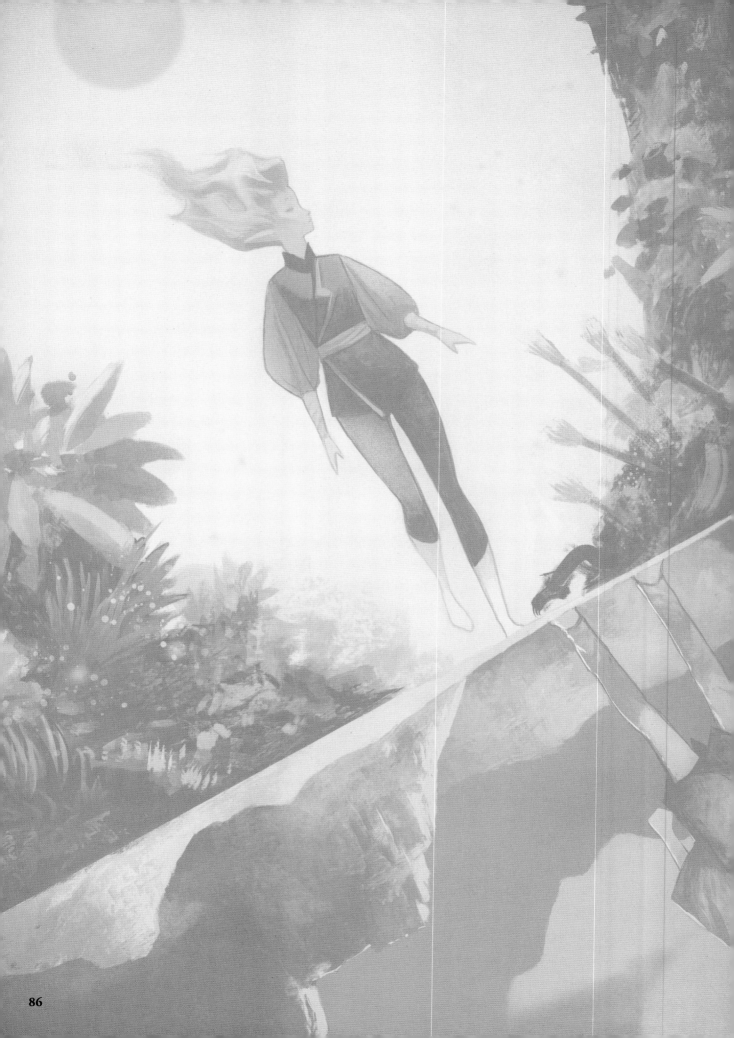

Jim Henson's™
THE POWER OF THE
DARK CRYSTAL™

An official sequel to the original film, *The Power of the Dark Crystal* graphic novel series introduces an all-new race of creatures called Firelings that live in a realm near the planet's core, based on official character designs by Brian Froud.

Following Pages: *Art by Jae Lee with June Chung* (left) and *art by Kelly and Nichole Matthews* (right)

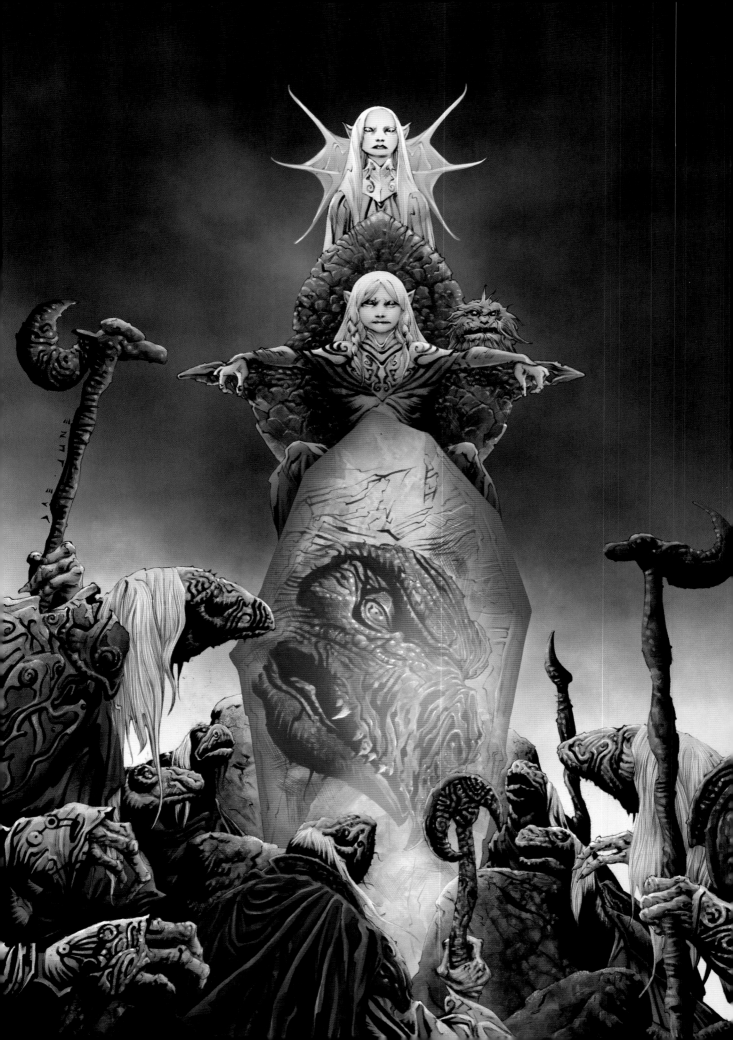

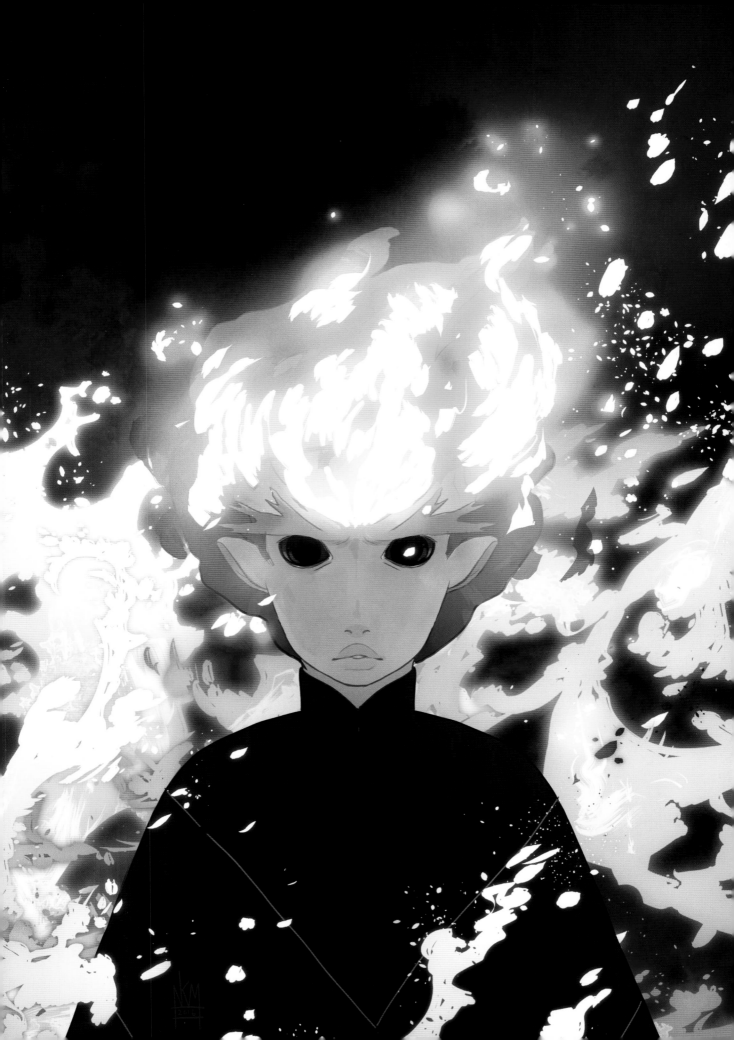

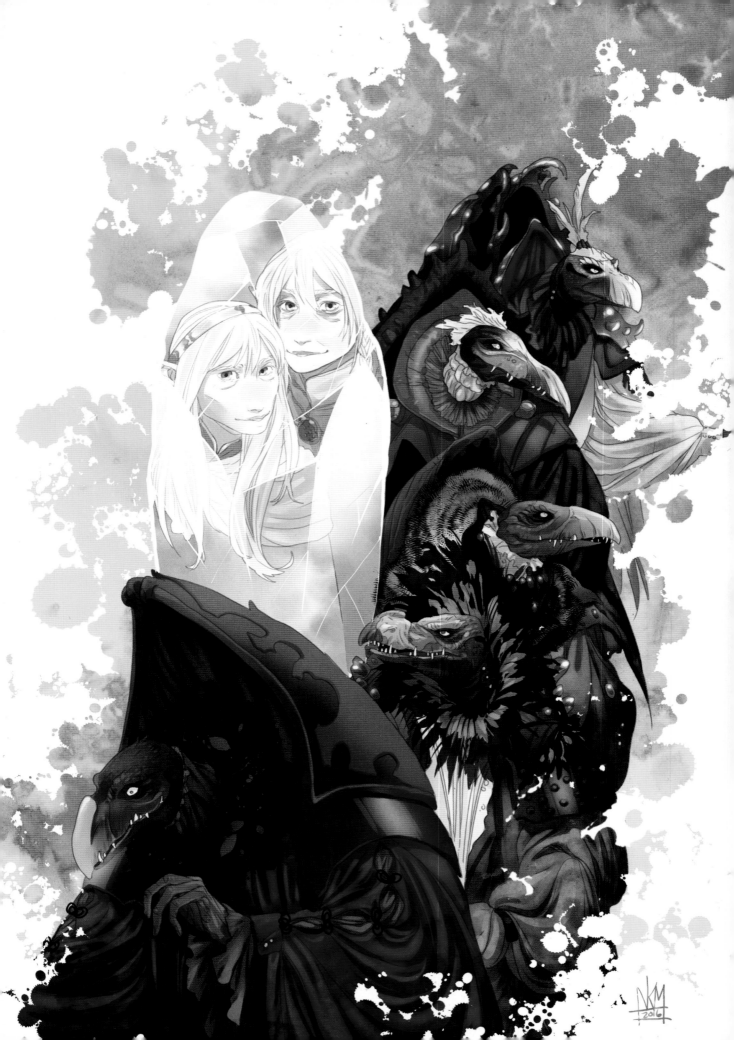

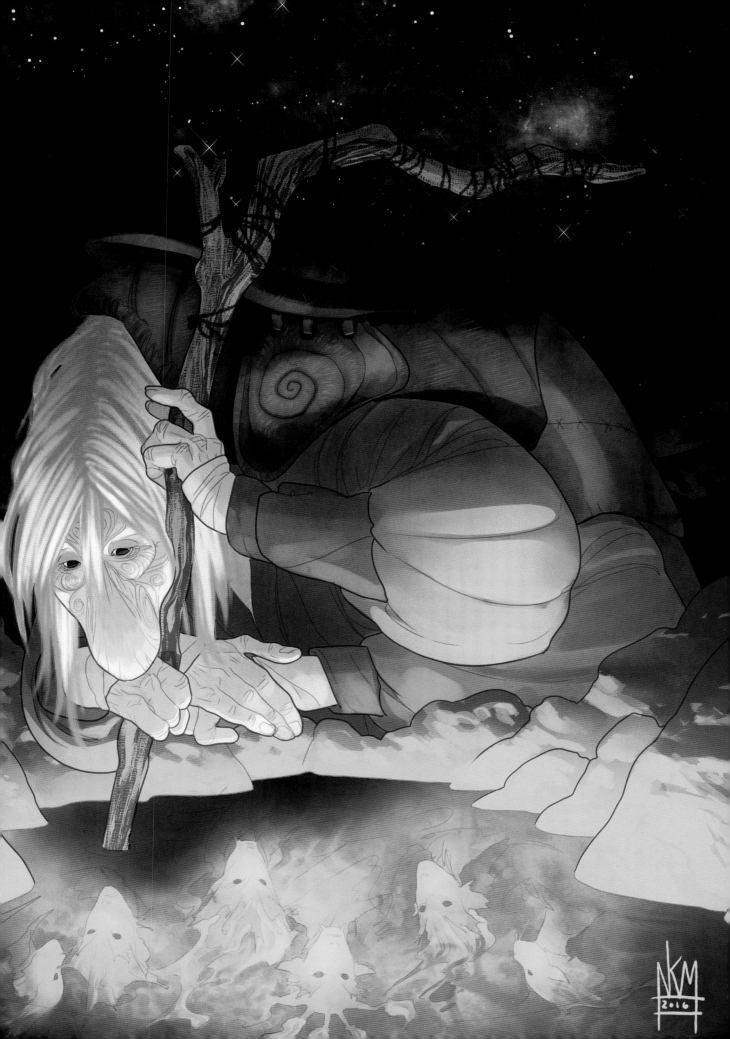

> **"Today all of Thra shall become enmeshed... in the Fireling's fate."**

Previous Pages: *Art by Kelly and Nichole Matthews*. Facing Page: *Art by Jae Lee with June Chung.*
Following Pages: *Art by Mike Huddleston.*

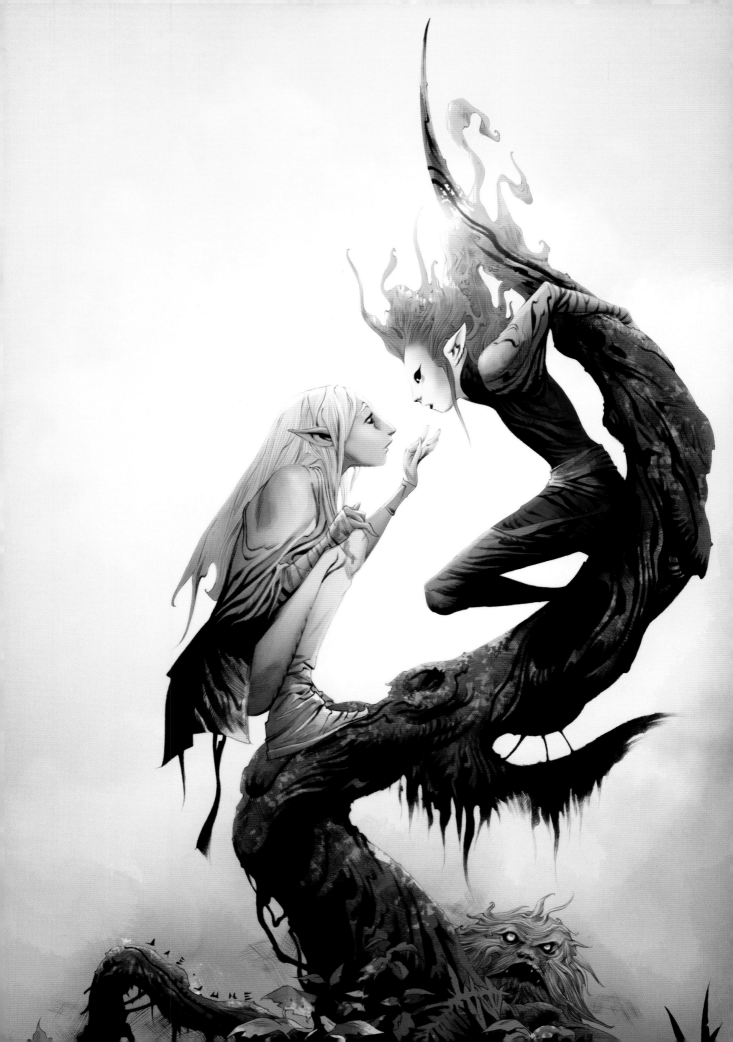

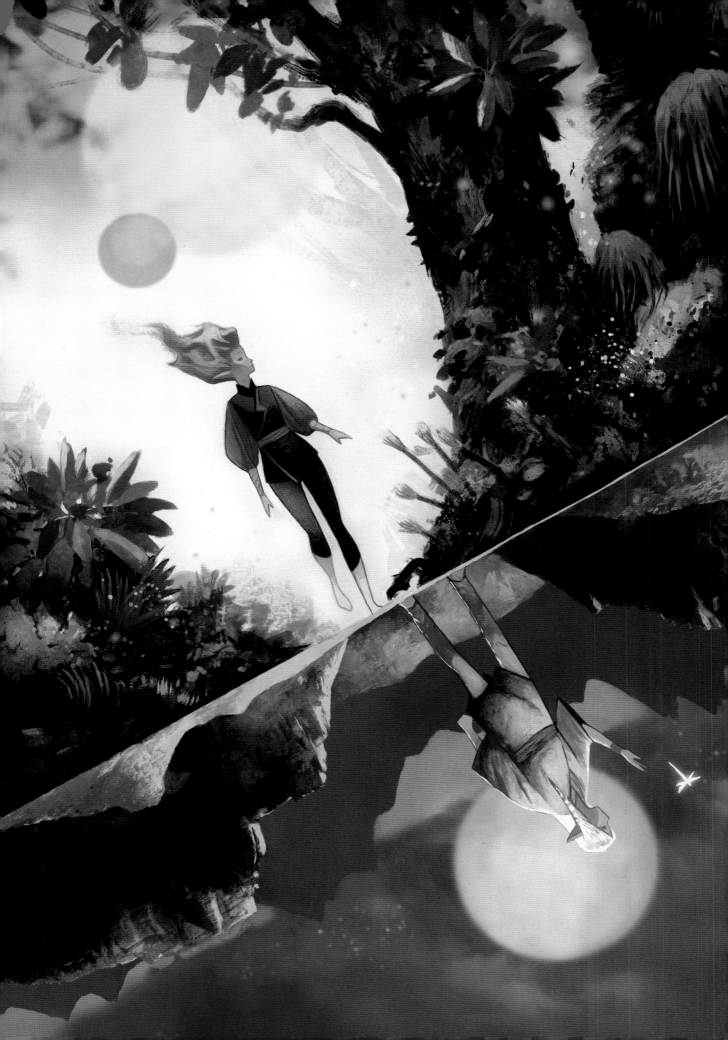

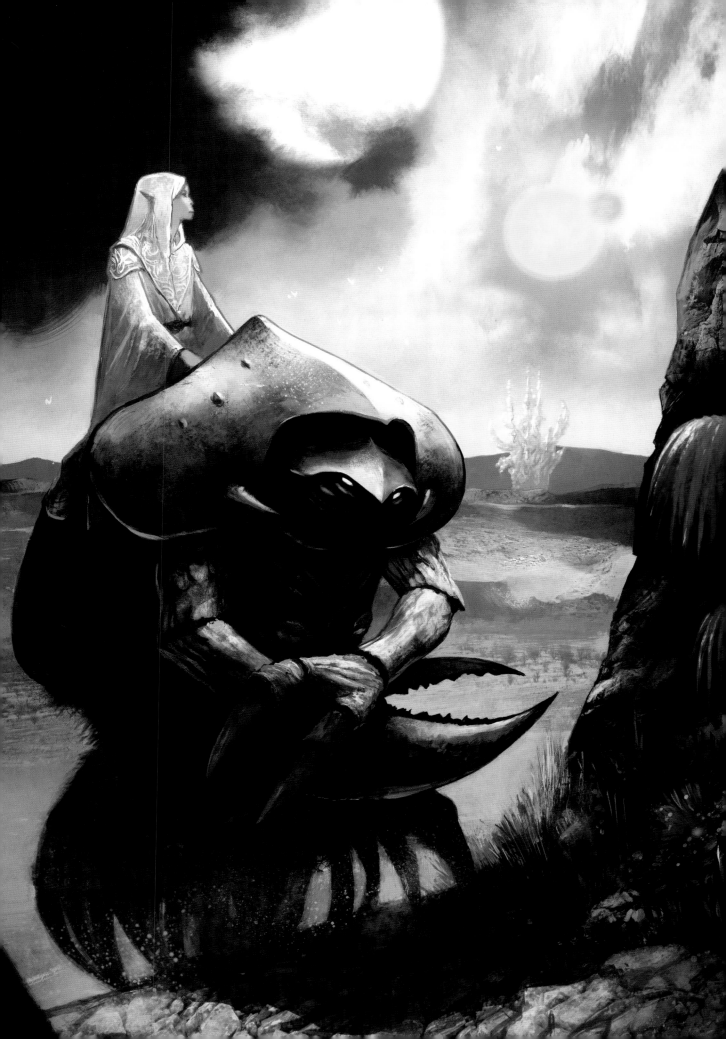

"Only a sliver of the great light...
the great power from the outer sphere...
can reignite the inner fire."

Facing Page: *Art by Mark Buckingham.*
Following Pages: *Art by Benjamin Dewey* (left) and *art by Jae Lee with June Chung* (right).

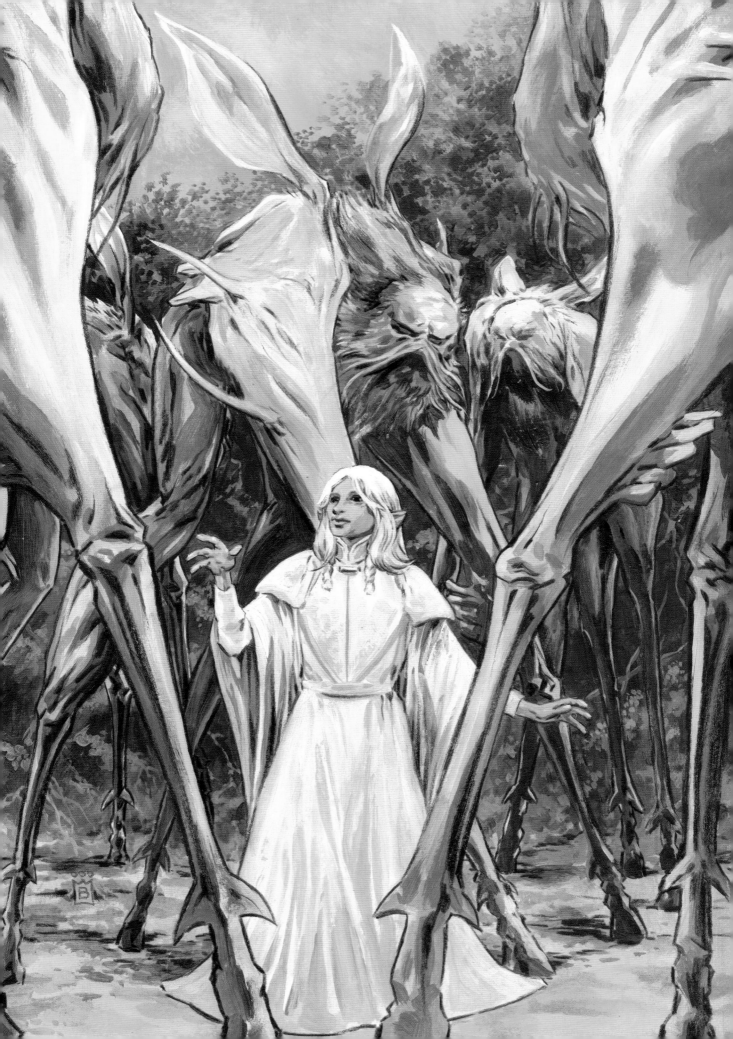

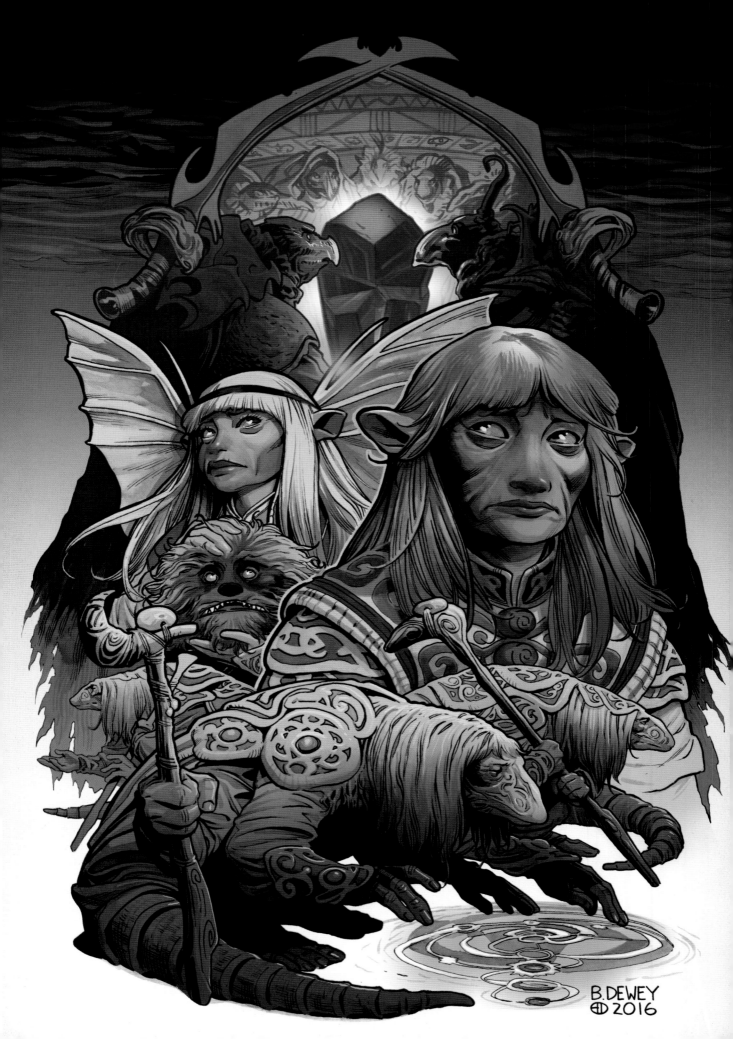

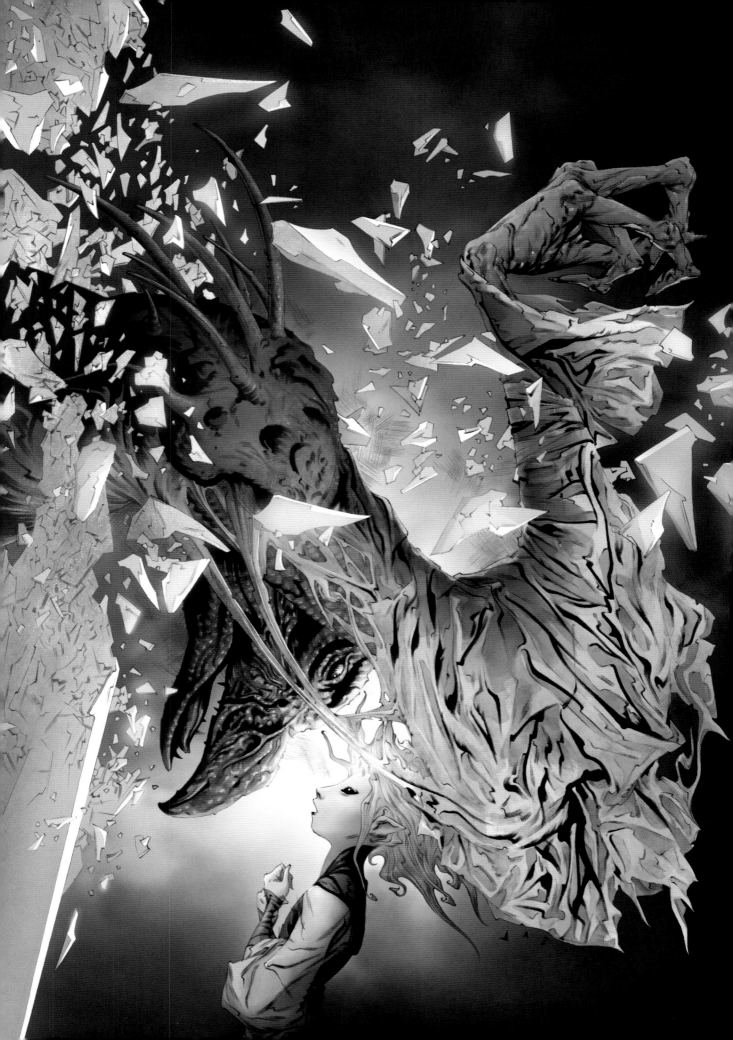

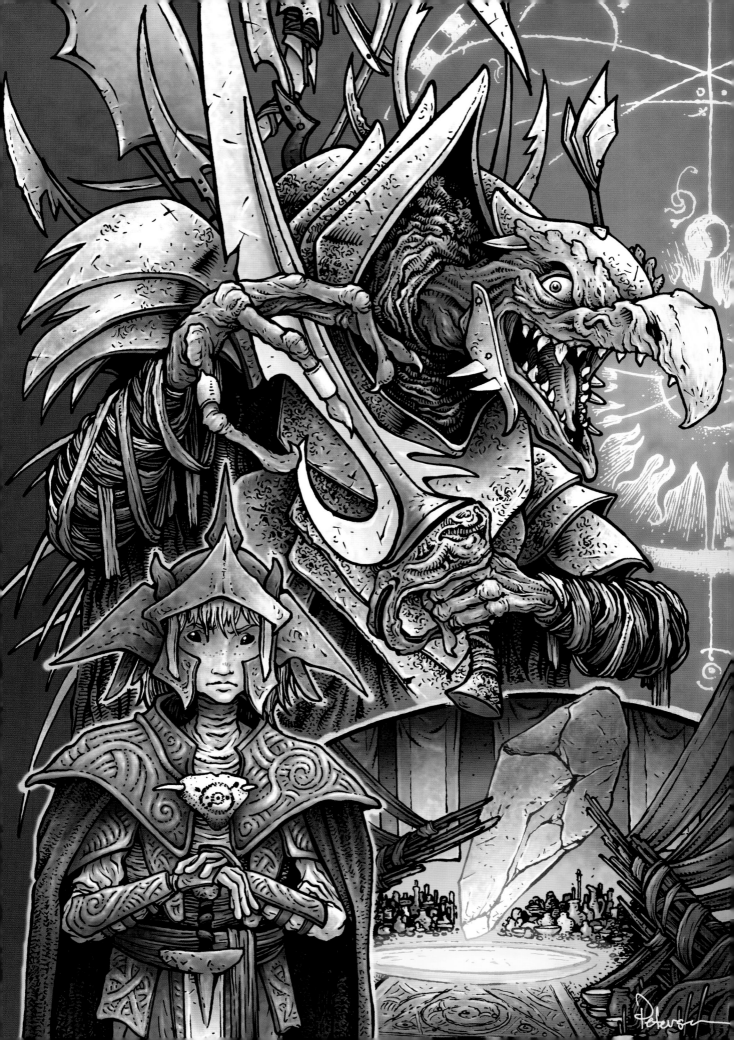

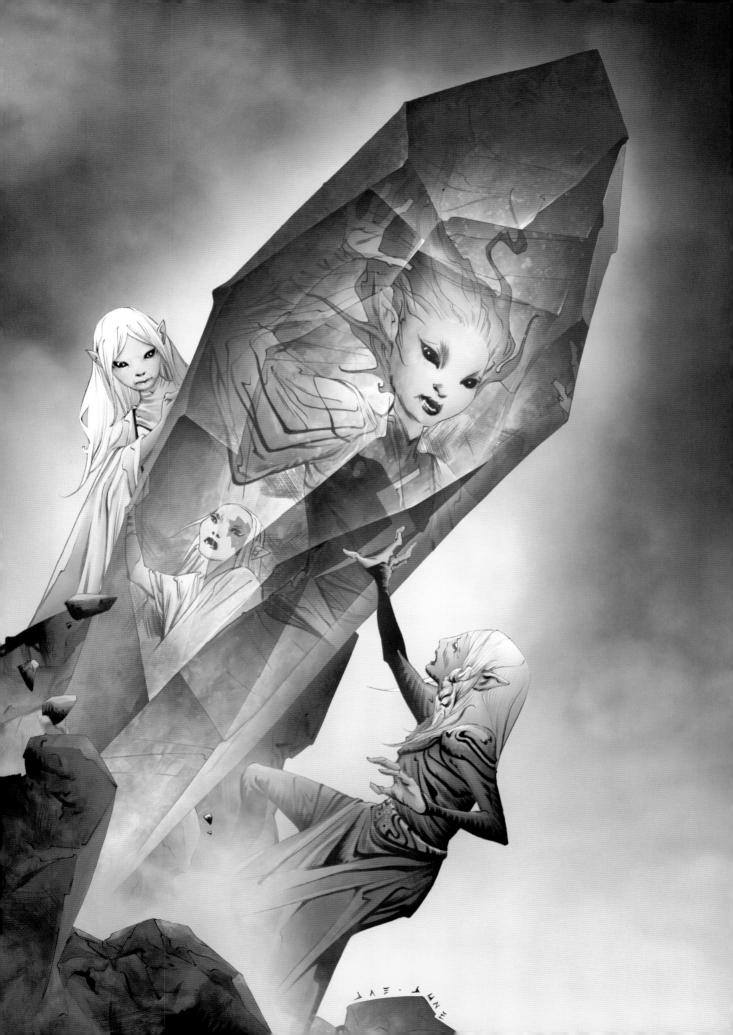

"When the mind is unclear, listen to the heart.
Never forget that both are parts of the whole."

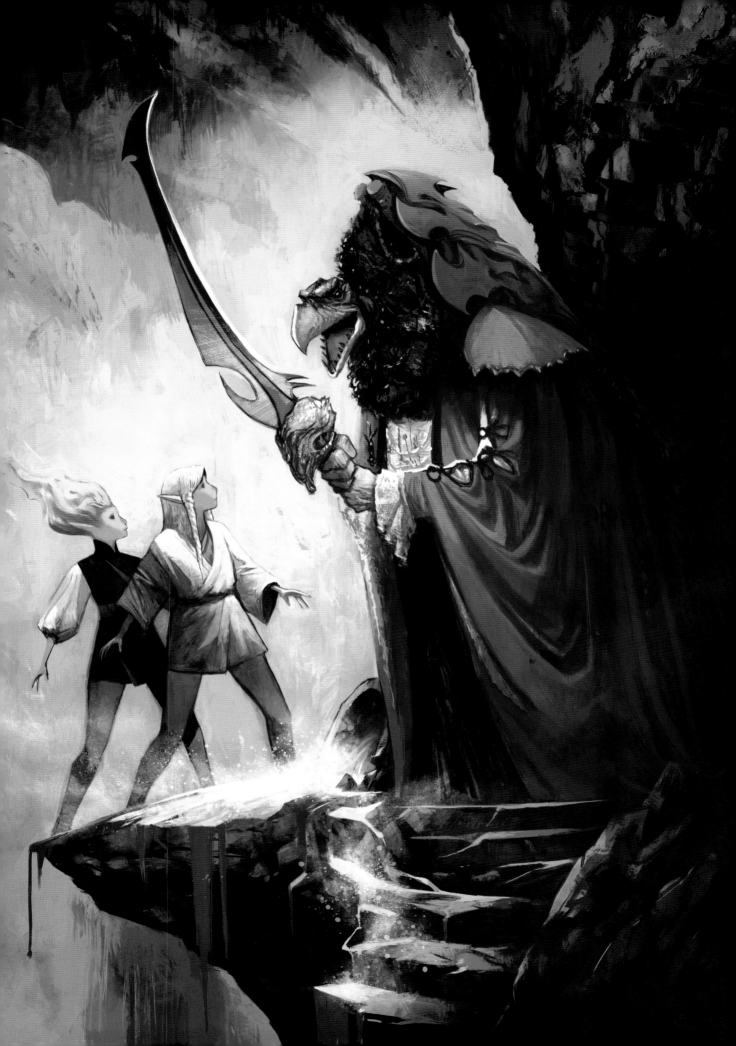

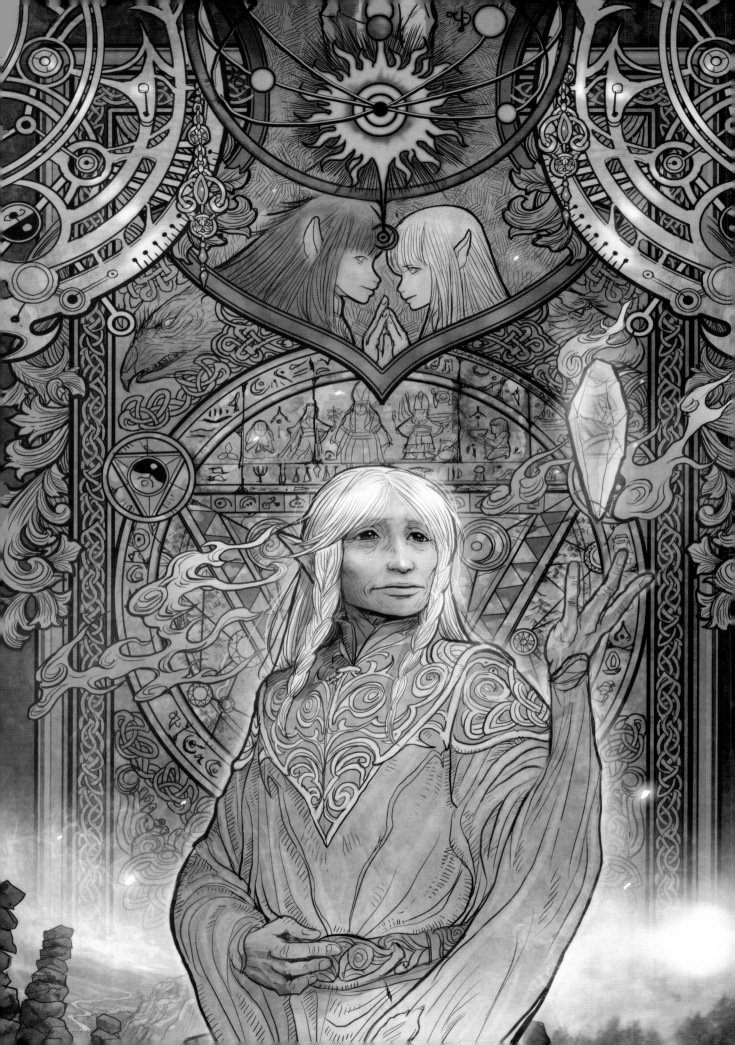

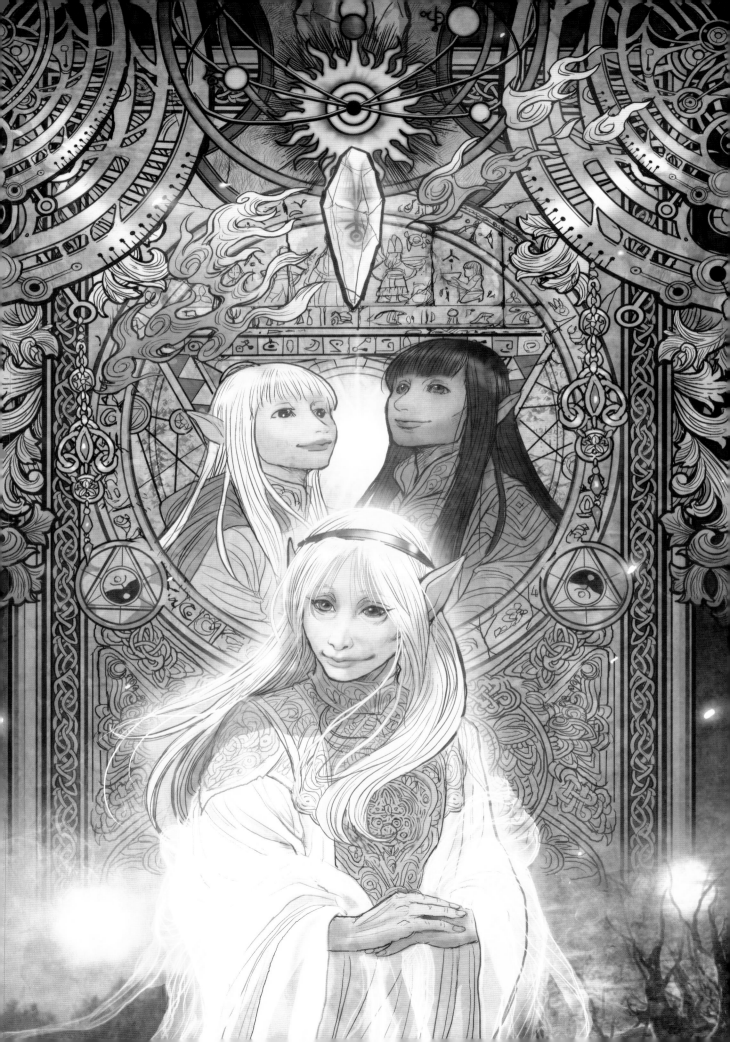

✦ ABOUT THE ARTISTS ✦

Michael Allred has been making comics full-time since January of 1990. This is when his "hobby" drawing comics started paying well enough to roll the dice and leave his previous career as a TV journalist in Europe. He relocated back to the U.S. to be a cartoonist while also dipping his toe in film, as well as recording two albums with his band, The Gear.

The move from Europe was justified soon after with the success of his Frank "Madman" Einstein creation, and the successful coloring career of his wife and partner, Laura Allred. The Eisner, Harvey, and Inkpot award-winning couple have worked together on several acclaimed titles including *The Atomics, Red Rocket 7, FF, Batman,* and *Silver Surfer*. Michael Allred, along with Chris Roberson, also co-created *iZOMBIE*, which is now a hit TV series.

Josh Bodwell is no stranger to the world of *The Dark Crystal*. He was responsible for the new artwork featured on the 35th anniversary soundtrack release. Apart from his illustration work, he is most notably known as a professional tattoo artist and his signature brand of art permanently adorns the skin of pop culture fans worldwide.

Mark Buckingham has been working in comics for over twenty-eight years, building a reputation for design, storytelling, and a chameleon-like diversity of art styles on titles like *The Sandman, Death,* and *Peter Parker: Spider-Man*. Starting in 2002, Mark was the regular artist on *Fables* for Vertigo/DC Comics, working with its writer and creator Bill Willingham, for which they have earned numerous comic industry awards. Mark recently reunited with Neil Gaiman as they returned to work, after a twenty-two year wait, on *Miracleman* for Marvel Comics.

Dylan Burnett is a Canadian comic book artist living just outside Toronto. He is the artist and Co-Creator of *Interceptor* as well as its sequel *Reactor,* and has been the artist on such projects as *Weavers* with BOOM! Studios and *Doctor Spektor* with Dynamite Entertainment. His work is mainly influenced by punk rock music, which is probably why he likes drawing lots of angsty people in spikey leather jackets. Find him on twitter and instagram @dylrburnett.

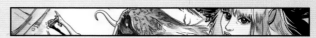

Jonathan Case is an Eisner-winning cartoonist from Portland, Oregon (land of comics). Case's graphic novel *The New Deal* was one of Amazon's Best of 2015 and a Reuben and Harvey nominee. His first book, the critically acclaimed *Dear Creature*, is also now available from Dark Horse in deluxe hardcover.

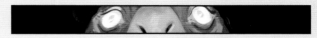

Hannah Christenson creates illustrations for books, comics, editorials, and games. Her work has been recognized by a variety of publications including *The Society of Illustrators* and *Spectrum*. When she's not working, Hannah can most often be found adventuring on some side-quest in search of treasures with her trusty canine sidekicks.

June Chung is an esteemed colorist who has worked on books for Marvel, DC, and many other publishers. She currently resides in Las Vegas, Nevada.

Jorge Corona is a graphic designer and sequential artist from the mythical land of Maracaibo, Venezuela. He is a comic book artist for several titles including *Feathers, Big Trouble in Little China: Old Man Jack, No.1 With A Bullet, We Are Robin,* and *Goners.*

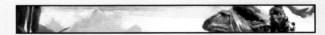

Jared Cullum is a father, writer-cartoonist, and painter of things with a passion for connecting with people through compelling visual storytelling. Based in Richmond, Virginia, he teaches figure anatomy and plein air painting at the Visual Arts Center.

Simone D'Armini was born in Rome in 1988 and studied graphic design and advertising before focusing his attention on comics and illustrations, attending Scuola Romana dei Fumetti (The Roman School of Comics). He illustrated his first graphic novel *The Spider King* in 2015, written by Josh Vann and funded through Kickstarter. *The Spider King* was re-published in four issues by IDW Publishing starting February 2018. Simone also collaborated with Oxford University Press and Éditions Glénat in 2016 and has been teaching inking and composition in his former art school. He currently lives in Dublin where he's working on a new comic book project that will be published in France in 2018.

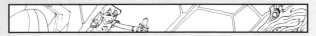

Brandon Dayton has worked in animation, illustration and concept art. He has created concept art for multiple titles for EA Games and for *Disney Infinity*. In 2008, he contributed writing and art to Impact Book's *Making Faces*. In 2009 he self published his first mini-comic, *Green Monk* which was selected for the YALSA Top Ten Great Graphic Novels for Teens Booklist. He lives in Salt Lake City, Utah with his wife, Annie and his two awesome children, Lucy and Grey.

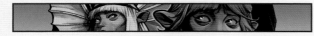

Benjamin Dewey is a fan of Carl Sagan/science, guitars/stringed instruments, Motörhead/Rock n' Roll, *Skyrim/Mass Effect*, and cats/animals. He lives in Milwaukie, Oregon with a sweet woman named Lindsey and three feline mischief-machines.

Michael Dialynas is a comic artist and beast wrangler that resides in Athens, Greece. He is the illustrator and co-creator of *The Woods* with James Tynion IV and *Lucy Dreaming* with Max Bemis over at BOOM! Studios. He has also been involved with IDW's *Teenage Mutant Ninja Turtles* and DC's *Gotham Academy*. When he's not chained to the desk drawing comics, he tries to live a normal life and see the Earth's yellow sun every now and then. See more of his work at WoodenCrown.com.

Gustavo Duarte is a cartoonist and a comic creator born in São Paulo, Brazil. For the last twenty years, he has published comics and illustrations in the most important publications in Brazil. In 2009, he started publishing his own comics like *Monsters!, Có!, Birds,* and others. He published a collection of his short stories in *Monsters! And Other Stories* through Dark Horse Comics, and has worked with DC Comics, Marvel, and BOOM! Studios.

Jay Fosgitt has drawn for many familiar properties, such as *Sesame Street* and *Dreamworks Animation Magazine* (Ape Entertainment), *My Little Pony, G.I. Joe/Micronauts/Transformers,* and *Popeye* (IDW), *Adventure Time, The Amazing World of Gumball,* and Jim Henson's *Labyrinth* and *The Dark Crystal* (BOOM!), *Betty and Veronica* and *Little Sabrina* (Archie), and *Rocket Raccoon and Groot, Avengers, Gwenpool, Web Warriors, Champions, Deadpool, Jessica Jones* and *Not Brand Echh* (Marvel). Jay has also written and drawn his creator-owned titles *Dead Duck*

and Zombie Chick (Source Point Press), *Necronomicomics* (Rue Morgue), and *Bodie Troll* (BOOM!). He resides in Plymouth, Michigan with his cat, Goonie.

Brian Froud is known worldwide as the preeminent faery artist of our time. He has published over twenty-five books, including the best selling *Faeries, Lady Cottington's Pressed Faery Book*, and many more. In 2012 Brian and his wife Wendy released *Trolls*, a major hardcover book published by Abrams Books. Brian worked with Jim Henson for many years and was the designer for the iconic films *The Dark Crystal* and *Labyrinth*. Brian's art is represented in collections throughout the world and can be seen at Animazing Fine Art in New York.

Lee Garbett is a renowned comic book artist hailing from the United Kingdom. Some of his notable works include *Lucifer, Batman, X-O Manowar,* and *Loki: Agent of Asgard.* He is currently working on the original series *Skyward* for Image Comics with Joe Henderson, showrunner of the hit TV series *Lucifer*.

Cory Godbey creates fanciful illustrations for films and books, including Jim Henson's *Labyrinth Tales* and *The Dark Crystal Tales* from BOOM! Studios. His award-winning work has been featured in many esteemed annuals, including *Spectrum: The Best in Contemporary Fantastic Art* and *The Society of Illustrators*. He enjoys meeting new creatures and hikes through twisting paths with friends. Cory lives with his family and a pack of stray cats in Greenville, South Carolina. Visit him at www.corygodbey.com.

Nicole Gustafsson is an artist and illustrator living in the Pacific Northwest. Originally from Nebraska, she loves the outdoors and continues to be inspired by the natural world. Nicole specializes in traditional media paintings featuring themes of adventure and exploration in the fantastical environments. To view Nicole's latest venture, visit www.Nimasprout.com.

Ian Herring is an Eisner nominated colorist that split his youth between small town Ontario and smaller town Cape Breton. He was raised on Nintendo and reruns of

The Simpsons. Somewhere during this time, he learned to draw and color. He has worked on countless projects for Marvel, DC, IDW, and BOOM! Studios including *Ms. Marvel, Silk, The Flash*, Jim Henson's *Tale of Sand*, and *TMNT*.

Justin Hilden lives and works in Los Angeles. He is a senior illustrator at The Jim Henson Company and loves working with classic properties like *The Dark Crystal*. He also creates animated shorts and collaborates with his wife, writer Autumn Hilden, in their cottage studio. See more of his work at justinhilden.com.

Mike Huddleston is an award-winning illustrator, and has worked for every comic book company he can think of. Most of the time he's working on stuff like *Harley Quinn*, or *The Strain*, but occasionally he creates his own projects like *The Coffin*, with Phil Hester, or *Butcher Baker*, with Joe Casey. He lived in France for a while, which was pretty weird, and now lives in Hollywood, which sounds way more glamorous than it really is.

Lizzy John lives in Brooklyn and spends most of her days there drawing pretty pictures. Sometimes she gets paid for it.

Kimberli Johnson is a comic creator and illustrator who grew up watching 80's fantasy films and reading *The Chronicles of Narnia* and Tolkien, which have inspired her throughout her life. She is also a huge fan of woodland critters and all animals which show up in her artwork frequently. She aspires to one day own enough pets that she could start a small petting zoo, and to create art and stories that make people happy.

Derek Kirk Kim is an award-winning writer, artist, and filmmaker. He is the writer of the *Tune* series, the writer and director of the spin-off web series, *Mythomania*, and a character designer of *Adventure Time*. He won all three major comics industry awards, the Eisner, the Harvey, and the Ignatz Award for his debut graphic novel, *Same Difference and Other Stories*. He won a second Eisner Award for his work on *The Eternal Smile*, a collaboration with National Book Award-nominee, Gene Luen Yang. He eats chips with chopsticks. Discover more at www.derekkirkkim.com.

Jae Lee is an Eisner Award-winning comic book artist who resides in Las Vegas, Nevada. His notable works include *Inhumans*, *Stephen King's The Dark Tower*, *Batman/Superman*, and *Before Watchmen: Ozymandias*. Find more of his work at www.jaeleeart.com.

Sonny Liew is a Malaysian comic book artist based in Singapore. His book *The Art of Charlie Chan Hock Chye* was a New York Times and Amazon bestseller, and the first graphic novel to win the Singapore Literature Prize. Other works include *The Shadow Hero* (with Gene Luen Yang), *Doctor Fate* (with Paul Levitz), and *Malinky Robot*, as well as titles for Marvel Comics, DC Comics, DC/Vertigo, First Second Books, BOOM! Studios, Disney Press and Image Comics. He has won multiple Eisner Awards for his writing and art and for spearheading *Liquid City*, a multi-volume comics anthology featuring creators from Southeast Asia.

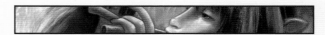

Ashly Lovett is an illustrator and gallery artist currently living in Louisiana. Working primarily with chalk pastel, she loves creating illustrations for the horror and fantasy genre, often with a dark romanticism undertone and Pre-Raphaelite influence. Her work has been published in *Spectrum Fantasy Art Annual 22, 23*, and *24*, *Society of Illustrators of Los Angeles, Infected by Art*, and others. Clients include BOOM! Studios, Hackle TV, ArtOrder, and more. She's done licensed work for The Jim Henson Company, Adult Swim, Netflix, Focus Features, Archie Comics and more.

Celia Lowenthal is a comic artist and illustrator with a penchant for drawing patterns and puffy period sleeves. She cites folklore, mythology, and early literature as some of her biggest inspirations. She has a BFA from the Maryland Institute College of Art, received the 2015 Will Eisner Scholarship Award from the Society of Illustrators, and lives in New York.

Ann Marcellino is an experienced illustrator and concept artist who has worked in television, mobile games, books, toy design, and a range of other projects. To see more of her work, find her on Tumblr at www.annmarcellino.tumblr.com or Facebook at www.facebook.com/annmarcellinoart/.

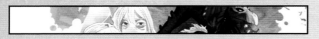

Kelly and Nichole Matthews are a twin art duo living north of the Emerald City. They are the artists for Jim Henson's *The Power of the Dark Crystal* for Archaia, as well as Archaia's *Toil and Trouble*, and *Breaker* for Stela Comics. They've drawn comic book covers for Valiant Comics's *Faith* miniseries and the BOOM Box/DC Comics crossover event *Gotham Academy/Lumberjanes*.

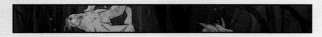

Sas Milledge is an aspiring illustrator and comic artist from Melbourne, Australia. In 2016 she completed her bachelors in animation at RMIT, and in 2017 studied drawing and visualization at the Animation Workshop in Denmark. She works as a freelance illustrator and she writes and draws the webcomic *Mimon*.

Robb Mommaerts is a professional cartoonist and illustrator living and working in the frigid state of Wisconsin. When he's not chasing after his two young kids and a dog, he's down in his basement office/dungeon toiling away at silly pictures. The worlds of Jim Henson and Brian Froud had a profound impact on his creative development as a child and still do to this day.

Dan Mumford is a freelance illustrator working out of Studio100 in central London, UK. Over the past 10 years, Dan has worked within the pop culture and music scene, creating everything from album covers, branding and screen-prints to new interpretations of classic film posters and albums. Clients include Disney, Sony, Iron Maiden, Wizards of the Coast, Icon Motosports, CBS and many, many bands and record labels from around the world.

Holly Myer studied animation at NYU during the rise and reign of Liz Lemon, resolute in her quest for a career in humor and absurdity. She has since worked at Nickelodeon, DreamWorks, The Jim Henson Company, and Disney, proud to have been part of bizarre conversations like, "Should we call it 'rainbow butt' or 'butt rainbow?'" See her pop culture portraits, coloring books, and sassy greeting cards at www.hollygolightning.etsy.com.

Ramón K. Pérez is a multiple Eisner and Harvey Award-winning cartoonist best known for his graphic novel

adaptation of Jim Henson's *Tale Of Sand*. Other notable works include *All-New Hawkeye*, *Spider-Man: Learning To Crawl*, *Nova*, *John Carter: The Gods Of Mars*, along with *Butternutsquash* and *Kukuburi*.

David Petersen was born in 1977. His artistic career soon followed. A steady diet of cartoons, comics, and tree climbing fed his imagination and is what still inspires his work today. He is a three time Eisner Award winner and recipient of two Harvey Awards for his continued work on the *Mouse Guard* series. David received his BFA in printmaking from Eastern Michigan University where he met his wife Julia. They continue to reside in Michigan with their dogs Bronwyn & Coco.

Benjamin Schipper loves to create artwork and illustrations that have sad, spooky, and poignant emotions. He likes people in general, and animals in particular. He lives in New York City with his wife Karen and their little black dog Willow. The majority of his work is traditionally drawn in pencil on marker paper, scanned into Photoshop, and colored there.

Alex Sheikman was born in the USSR, immigrated to the U.S. at the age of twelve, and shortly thereafter discovered comic books. Since then, he has contributed illustrations to a variety of role-playing games published by White Wolf, Holistic Design, and Steven Jackson Games. He is also the writer and artist of *Robotika, Robotika: For A Few Rubles More, Moonstruck*, and a number of short stories. He was also the interior artist on *The Dark Crystal: Creation Myths* trilogy from Archaia. He lives in Northern California.

Hayden Sherman is an award-winning comic artist whose work includes *The Few* (which he co-created with Sean Lewis), *John Carter: The End, Cold War*, and *Wasted Space*. He's a lover of science-fiction and fantasy who has had the joy of illustrating for companies such as Marvel, Image, Dark Horse, Dynamite, AfterShock, Vault, and BOOM! Studios. He currently resides in Boston, Massachusetts, where he shares an apartment with his significant other, a couple of oddballs, and a cat.

Mac Smith spawned from the meth-soaked swamps of the American South and has lumbered west across the desert wastes and desolate mountains to lay his eggs in the heart of the Pacific Northwest. His only weapons are confidence born out of ignorance and militant contrarianism. He enjoys bad movies, playing with his extremely dumb dog, and drawing muppets.

Matt Smith lives in the troll-infested suburbs of Boston, Massachusetts with his lovely wife Kathleen and their small wolflet, Jackie. Matt wrote and drew *Barbarian Lord*, a grim and determined love letter to all things Icelandic saga-y and *Conan*-ish. He also fought hideous aliens alongside Nathan Fairbairn in the *Lake of Fire* series for Image Comics.

Jeff Stokely is the Eisner and Harvey Award-nominated co-creator of *The Spire*, and artist of *Six-Gun Gorilla*, *The Reason for Dragons*, and *Piper*. Hailing from central California, Jeff taught himself to draw to the background noise of 90's anime and heavy metal. He can be found chained to his desk, inhaling unhealthy amounts of coffee, pizza, and shonen manga. (Often at the same time.) Jeff currently resides in Seattle, Washington with his majestic beard and definitely not fictional girlfriend.

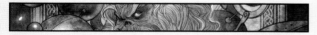

Sana Takeda is an artist and illustrator based in Tokyo, Japan. After working as a designer at SEGA Corporation, she became a freelance illustrator. In America, she has worked for Marvel and is the artist of the Hugo Award-winning comic series *Monstress*. She draws illustrations of games in Japan, picture books for children, and more.

S.M. Vidaurri was born and raised in northern New Jersey. His previously published works include Jim Henson's *The Storyteller: Witches* and the original graphic novels *Iron: Or, the War After* and *Iscariot*. His apartment is filled with many animals. He can be found at www.smvidaurri.com.

David Jesus Vignolli is a Brazilian graphic novelist and author of *A Girl in the Himalayas*. The first time he watched *The Dark Crystal* he was 10 and he was terrified by Aughra.

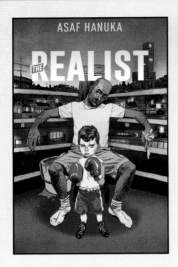

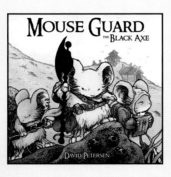